粉彩笔记

精品粉彩技法 （第二版）

冉茂芹 …… 著

广西美术出版社

GUANGXI FINE ARTS PUBLISHING HOUSE

PASTEL NOTES

图书在版编目（CIP）数据

粉彩笔记：精品粉彩技法 / 冉茂芹著 . —2 版 . —南宁：广西美术出版社，2021.6

ISBN 978-7-5494-2387-3

Ⅰ . ①粉… Ⅱ . ①冉… Ⅲ . ①色粉笔画—写生画—绘画技法 Ⅳ . ① J215

中国版本图书馆 CIP 数据核字（2021）第 091014 号

粉彩笔记

——精品粉彩技法（第二版）

FENCAI BIJI

JINGPIN FENCAI JIFA（DI-ER BAN）

著　　者：冉茂芹
出 版 人：陈　明
终　　审：杨　勇
图书策划：吕海鹏
责任编辑：吕海鹏　刘　丽
封面设计：陈　凌
版式设计：中　豪
美术编辑：李　力
摄　　影：潘家祥
翻　　译：吴书娴
校　　对：张瑞瑶　李桂云
审　　读：陈小英
监　　制：莫明杰
出版发行：广西美术出版社
地　　址：南宁市望园路 9 号
网　　址：www.gxfinearts.com
邮　　编：530023
印　　刷：广西壮族自治区地质印刷厂
版　　次：2021 年 6 月第 2 版
印　　次：2021 年 6 月第 1 次印刷
开　　本：787 mm×1092 mm 1/16
印　　张：5.5
字　　数：68 千字
印　　数：1-2000 册
书　　号：ISBN 978-7-5494-2387-3
定　　价：58.00 元

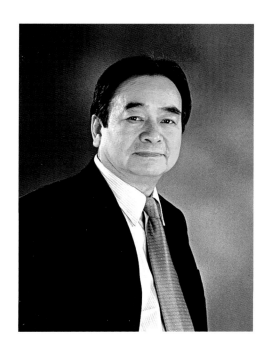

冉茂芹简介

1942 年出生于中国湖南省桃源县。

1965 年毕业于广州美术学院舞台美术专科。

1980 年移居中国香港。

1989 年定居中国台湾。

现为广东画院院聘画家，湖南师范大学美术学院客座教授，湖南文理学院客座教授，湖南常德工艺美术学校荣誉校长。1974 年年画作品《送戏上船》入选全国美展；1978 年油画作品《战士的歌》获广东省美术作品展一等奖；作品《灯下的女人》获美国《艺术家杂志》2005 年封面竞赛大奖，同年该作品还获得美国 Greenhouse Gallery 国际沙龙年度竞赛头奖；作品《铜手镯》获美国肖像画协会 2005 年度竞赛一等奖。其先后在中国香港、台湾和湖南等地举办个人画展 10 余次，出版个人专集近 30 种。

About Mau-kun Yim

Born in Taoyuan county of Hunan Province in China in 1942.

Graduated from Guangzhou Academy of Fine Arts in 1965.

Moved from Mainland China to Hong Kong in 1980.

Settled in Taiwan in 1989.

Yim currently holds several positions in China, including Overseas Artist of Guangdong Art Academy, Visiting Professor of Hunan Normal University, Visiting Professor of Hunan University of Arts and Science, and Honorary President of Changde College of Crafts and Fine Arts. In 1974, Yim's New Year pictures, *Send Drama to Boat*, was selected to National Fine Art Exhibition. In 1978, he received First Prize in the Guangdong Province Art Exhibition for his oil painting, *The Warrior's Song*. He received wide acclaim in the United States in 2005, garnering the annual cover award of The *Artist's Magazine* for his oil painting, *Lady in Shimmering Light*, which also won Best of Show at Salon International 2005 (held at Greenhouse Gallery). His oil painting, *Girl with Bronze Bracelet*, received First Place in the 2005 Portrait Competition of the Portrait Society of America. Yim has held many solo exhibitions in Hong Kong, Taiwan and Hunan, China etc. He is the author of nearly 30 books on oil painting and drawing.

粉彩画掠影（序）

冉茂芹

　　粉彩画的源头可追溯到原始人在岩洞石壁上的绘画，画家开始使用这种材料则是在 16 世纪。到 18 世纪 20 年代，威尼斯的女画家卡瑞拉(Carriera)推广粉彩画于巴黎。其后一连串的画家：夏尔丹(Chardin)、德拉克洛瓦(Delacroix)、米勒(Millet)、马奈(Manet)、雷诺阿(Renoir)、罗特列克(Toulouse-Lautrec)、勃纳尔(Bonnard)、惠斯勒(Whistler)，都喜欢使用粉彩作画。尤其是德加(Degas)，更是把粉彩发挥到极致。后来，他的学生卡萨特(Mary Cassatt)将粉彩画介绍给美国费城、华盛顿的上流社会，引进美国。

　　粉彩画在民国初年进入中国，成为上海月份牌美人画、年画的一种主要表现。南洋画家李曼峰在 20 世纪中叶留下了许多精彩的粉彩作品。新加坡画家萧学民长期使用粉彩画肖像和人体，技法精熟、画面生动，享誉东南亚。

　　目前，世界上已研发出多种粉彩纸和各种软硬度的粉彩色条，色条的色别已有 500 种以上。如选用 500 种色的色条作画，几乎到了不用混色的地步，只需不断地选色涂上便可。平面承载有粉彩纸（板），有砂纸，还有绒纸。不同的纸还有粗细之分和不同底色的区别，以适应不同软硬度的粉彩色条和作画者对底色的选择。

　　我初步尝试之后觉得砂纸较为好用，它较为留得住色彩，耐揉抹，可细可粗。但是，在同一个地方画上太多次也会变得平滑，不吃色。这时，补救办法是用木工细砂纸裁取小片把多余色粉磨松、吹掉，即可在此处重画。

　　选用 90 色粉彩，再补充一些个别单支色就可以作画了。色别不够多，非得多次混色和叠色，反倒造就出画面极丰富而微妙的色彩变化效果。混色，叠色，可以手揉或不揉，直接加上用色条做大笔触的描画，形成多节奏的画面效果。粉彩可以将色彩变化表现得既丰富又细腻，也可以将细节刻画得精细和准确，还可以笔触潇洒，线条飞舞。总之，虚与实、显与隐的对比均可自如呈现。只要不过厚，就能即刻覆盖和加色。与油画比，不必担心底色翻搅上来。与水彩比，不必担心水分不好控制，形会跑掉，真是一种妙不可言的画材！唯一麻烦的是，画完的作品不易保管，其实就是三个字"碰不得"，当然，配上画框，外面隔了玻璃或塑胶片就万无一失了。若不配画框，可以用赛璐珞片或描图纸裁好覆盖。也有喷上固定液的，但是会使色调加深，不理想。

　　粉彩画的色彩既艳丽又柔和，是大众喜闻乐见的画种。只要造型和色影关系不离谱，画幅多能得到人们的赞美。

　　粉彩画是个"娇小姐"，她像水蜜桃般粉嫩可爱，像杨贵妃般百媚生姿，但又柔弱如林黛玉，一点不能沾风带水，她要人呵护备至，金屋藏娇，真是太难伺候了。但是，不要忘了，粉彩又是众多画种里最稳定不变色的，可谓"观音菩萨，年年十八"。

　　我应广西美术出版社邀请，编辑了这本小册子，技法尚未全面，题材亦不广泛，只是抛砖引玉之举，并以此就教于粉彩前辈与同道。

2005 年 11 月于中国台北

Preface

By Mau-kun Yim

The origin of pastel can be traced back to chalk paintings of prehistoric caves. The earliest record of artists using pastel to paint dates back to the sixteenth century. In the 1720's, Venetian painter Rosalba Carreira introduced the medium to the Parisian art circle. Later artists noted for their works in pastel including: Jean Baptiste Simeon Chardin, Eugene Delacroix, Jean-Francois Millet, Edouard Manet, Auguste Renoir, Henri de Toulouse-Lautrec, Pierre Bonnard, and James Whistler. Among these celebrated names, Edgar Degas opened the way to the Renaissance of pastel in Europe by applying pastel to finished works rather than limiting it to a tool for sketching. His protegee, Mary Cassatt, introduced pastel to the American art scene through the high society on the Atlantic coast.

Pastel was introduced to Chinese at the beginning of the twentieth century. It gained wide popularity in the old calendar picture and New Year picture in Shanghai. Well-known pastel artists in Asia include Indonesian-born master painter Man-fong Lee, whose rich legacy of pastel paintings was considered pioneering works in the mid-twentieth century. Contemporary Singaporean artist Xue-min Xiao champions the Southeast Asian art world with his skillful and dynamic pastel paintings of nudes and portraits.

With the wide popularity and long history of pastel art, it is no wonder that an expansive array of tools has been developed for artists interested in this medium. There are various kinds of pastel paper and different grades of pastel crayons, ranging from hard to soft, for one to choose from. The range of colors is wide, offering more than 500 unique shades. If you choose a set of 500-colored pastel, you can paint directly with the crayons and spare the need for blending colors. In regards to paper, you can use pastel paper, pastel boards, sand paper or velvet paper. Boards of different textures offer different levels of strengths for retaining the pastel powder. You can choose the colors and surfaces that work best for your purposes.

I personally prefer painting dry pastel on sand paper, which retains the color powder and endures the spreading and blending necessary in working with pastel. Even sand boards are not always reliable if I apply too many layers of colors onto one area. The surface becomes too smooth to retain the powder. To remedy this problem, I use refined sand paper to remove the excess powder, blow it off and paint over it.

I generally work with a set of 90-colored chalks, adding more colors as needed. Since there is not a wide range of colors to choose from, I tend to blend and mix the colors very often, which results in a rich layering of colors and subtle differences in shades. The layering of colors together with the simple strokes created with pastel sticks produce a good painting with dynamic rhythms. Pastel is a versatile medium. You can create rich shades by hatching and dabbing or drawing details with accurate lines in different degrees of thickness. It is a perfect tool for creating the contrast between solidness and transparency. You can apply layer upon layers of colors as long as the surface does not become too thick. Unlike working with oils, you need not worry about stirring wet paint in the bottom layer. Neither do you need to worry about manipulating the water, as in watercolor painting. Pastel is an ideal medium to work with except for one aspect: the finished work is essentially powder on paper and therefore needs extra protection. It is recommended to frame the artwork under glass or plastic covers. To save framing costs, you can also cut vellum or celluloid covers into appropriate sizes to cover the painting. I prefer not to use sprays or fixatives because they darken the colors.

Pastel paintings are well loved by artists and the general public. It is not particularly difficult to create charming paintings with these bright yet subtle colors, provided that you set up relatively accurate composition and color relationships.

Even though pastel paintings require extra protection on the finished work, once framed, the colors do not change or fade with age. The finished work can be among the most stable among the different mediums of paintings.

It is a delight to share some of my pastel works in this book, which journals my own learning curve with pastels. Guangxi Fine Arts Publishing House is offering a series of books on pastels, which I believe will encourage more artists to develop their insight and talent in this lovely medium.

December 2005 in Taipei, China

目 录

CONTENTS

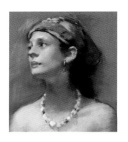

概　说

　　粉彩画很有意思,对于很多人而言,它像"巫山神女",既美丽又神秘。我初到台湾时曾尝试用它画了一幅裸女写生。后来,因为将绝大部分时间投入油画、肖像和风景画创作,而中断了好长好长的时间。直到 2002 年在教学中想起要增加新内容,才重新拾起粉彩色条,想不到竟一发不可收拾。除在台北的两个研习班外,远在台湾南部的高雄与台南的研习班学员也强烈要求我授以粉彩课程。延续下来,课程有半年之久,我的示范画作也累积了不少。当然,我也采用它画了些作品,毕竟它是很吸引人的。这本小书是这些作品的选集。

　　这不是专著研究,仅是我尝试使用这种材质作画的一点心得。将画作整理出来,找出一些过程记录和图片放在一起,配上一点作画时的方法和感想文字,有如笔记,三言两语般连缀起来就成了这本笔记小书。

Overview

　　Pastel is an interesting medium, especially because the colors convey a beautiful yet mystical ambience. The very first pastel painting I created was of a nude painted from life in the early 1990s. After that, I did not work with pastel for a long time because I spent most of my time creating oil paintings of different categories, including narratives, portraits and landscapes. A few years ago, when I began adding new curriculum to my teaching programs, the fun of working with pastel chalks came back to me. Never did it occur to me that this would mark the birth of a series of pastel paintings. My students from around

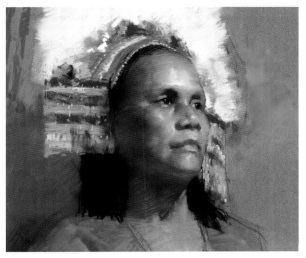

台湾少数民族妇人
（局部）

Woman of Ethnic Minorities in Taiwan (portion)

Taiwan, including those who attend my monthly seminars in southern Taiwan as well as those who come to my weekly classes in Taipei, also fell in love with pastel. Thus, my students and I focused on pastel for more than six months, during which I produced a significant number of studies done in class. I have also devoted time outside of class to paint pastel works. This booklet contains a selection of works from both sources.

　　While it is my passion to share my thoughts and ideas on pastel, this book does not attempt to offer a comprehensive study on the medium. Instead, it is a compilation of step-by-step records of my paintings, some techniques on how to manage pastel tools, and my reflections as an artist who paint from life.

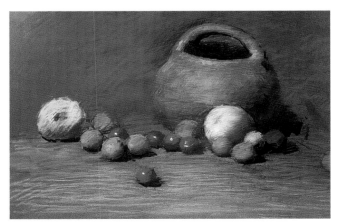

有提把的陶罐和水果　　The Clay Pot and the Fruits

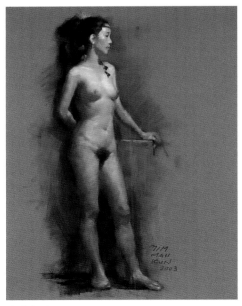

浓发裸女　　The Nude with Thick Hair

初 探

多年前刚开始上粉彩课时，我用的是普通的纸本粉彩纸。这种纸的色彩附着力不是很强，不能多遍反复着色。第一遍上色时，基础色就要选得比较准，要表现细致的冷暖变化不容易，色层可叠画上三四遍，再多就附着不了。这是我初使用粉彩纸的一些感觉。

右上图中的姑娘办过画展，曾到广州美院油画系攻读硕士学位，返回台湾后她也教学生。后来，我曾请她做模特画了油画《灯下的女人》，2005 年在美国赢得 Greenhouse Gallery 国际沙龙年度竞赛头奖及美国《艺术家杂志》(*The Artist's Magazine*) 封面竞赛大奖，这张粉彩就作为她做模特的酬谢了。

右下图中的美国女人长住中国台湾，说得一口流利的普通话，完全与台北人融成一片了。

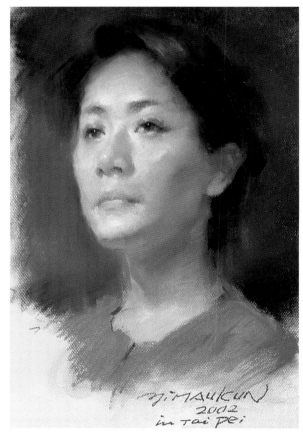

郑爱华　　　　　　　　　　Ms. Ai-hua Zheng

First Tries

When I first started teaching pastel, I struggled a bit with the limitations of the medium-the fact that pastel paper cannot retain many layers of colors. As a result, I needed to be very careful in selecting the base colors for the bottom layer. I could not afford to make mistakes. It was difficult to play out the subtle shades of the color temperatures because in any given area, the maximum number of colors could not exceed four layers. Otherwise, the color powder would not "hold".

The sitter of the painting in the upper right is herself a painter. She has held several exhibitions in Taiwan. With a master's degree in oil painting from my alma mater, the Guangzhou Academy of Fine Arts, she opened her own teaching studio a few years ago. I asked her to sit for an oil painting, titled *Lady in Shimmering Light*, which won the Best of Show at Salon International 2005 (held by Greenhouse Gallery in the United States) and the cover award of *The Artist's Magazine*. As a thank-you gift, I painted this pastel portrait for her.

The American woman of the painting in the lower right has called Taiwan her home for many years. She speaks impeccable Mandarin Chinese and has become part of the community in Taipei.

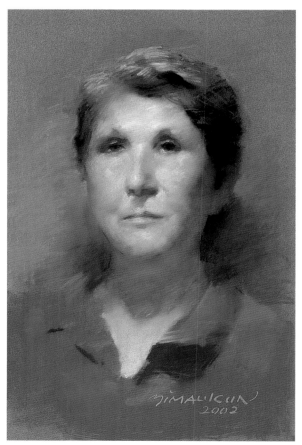

美国女人　　　　　　　　　　American Woman

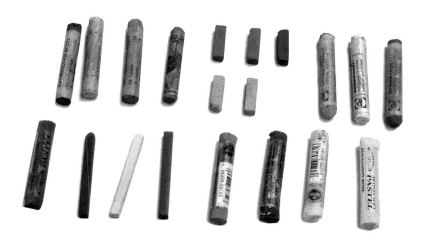

材　具

　　这是我作画用过的部分粉彩颜料。下面的大盒颜料分上、下两层，共 200 支，中间用泡沫海绵隔开。这大盒颜料是多年前我参加在美国举办的肖像画协会年度竞赛的奖品之一。

　　上面部分的小条颜料质地较硬，适合于细节描绘。在台湾的某些美术用品店有单支出售。

　　粉彩画的材料、工具都不复杂，只要有一盒颜料、一张粉彩纸和画板就可以马上画起来。

Tools

　　The images on the left show the pastel colors I use. The box-set of crayons in the bottom left is divided into top and bottom layers, with foam in the middle to separate the chalks. This box of 200 crayons was awarded to me as part of my prize at the Portrait Society of America's annual convention in May 2005.

　　The smaller chalks shown in the upper left are firmer in texture. They are good for drawing the details. Some art stores in Taiwan sell these separately.

　　The materials and tools for pastel are simple. One can start working with a minimum set of colors, a piece of paper or sand board.

基本画法

开始上粉彩课没多久，昵称为"石头"的画材商朋友就提供了一种新的粉彩纸——砂卡纸。这种纸是将极匀的细砂固定在卡片纸上，有不同的底色可供选用（现在美国还有坚实平直的砂板出售）。

我画粉彩的作画步骤与画油画相似：打完轮廓后，从深色、从暗部开始上色，待全部铺完色后再画细部。

从右上图中可以看到铺完色的状态。色彩尚未揉抹衔接，但大的深浅与冷暖关系都摆上去了。右下图是进一步细画后的面貌。

粉彩画可以用"间色"。"间色"的方法有如右上图，也可以揉抹、衔接得更细致柔和些，如右下图。想要怎样的画面效果任君选择，这里只是概略说明其基本画法。

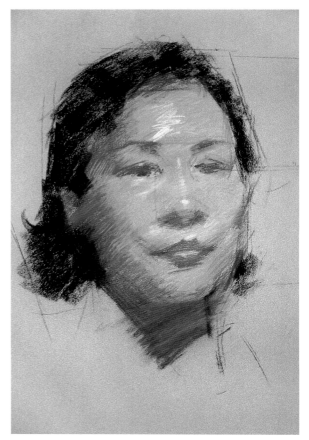

城郊妇人 (1)　　　　　　　　　　Suburban Lady (1)

Basic Techniques

A few days into my pastel teaching program, my art supplier and friend, whose nickname is "Mr. Stone", offered a new kind of pastel paper with sand on its surface. I immediately began working with this sandpaper because it comes in various base colors. A few suppliers in the United States manufacture pastel sand boards, which offer good support for the pastel powder.

The steps I take in creating a pastel painting are very similar to those in an oil painting: once I finish drawing the outlines, I block-in the colors from dark to light. Then I return to the details.

The image on the upper right shows the painting after the block-in stage. The colors are not yet blended together. However, the contrast between dark and light and that between cool and warm colors can be seen clearly. The picture in the lower right shows further details.

With pastel, you can leave spaces in between the strokes, as seen in the upper image. You can also blend and mix the colors, creating the more refined painting as shown in the lower image. It is the painter's choice to select a desired style of painting.

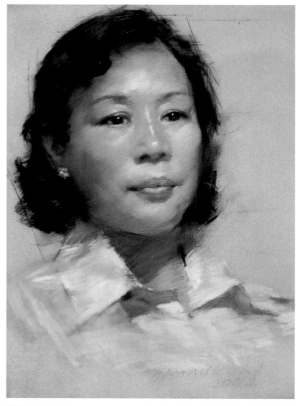

城郊妇人 (2)　　　　　　　　　　Suburban Lady (2)

静物练习

初画粉彩就画人物难度较大，不妨先做静物练习。这样可以让我们有充裕的时间来熟悉粉彩的材料特性。

这是一幅水果静物画的典型过程图。左边是起稿阶段，我首先注意怎样构图。构图，就是对实景的"裁切"，裁切进画面的所有物象应该是有主有次的，而且能体现出你的构图喜好。要注意以下几点：一是物象本身的造型特点，二是它们之间的比

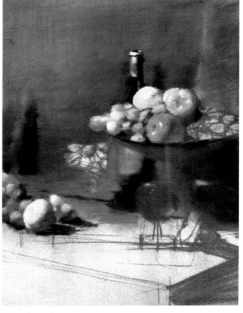

水果与红酒 (1)　　　　Fruits and Wine(1)　　　水果与红酒 (2)　　　　Fruits and Wine(2)

例，三是它们之间的空间位置：前后及左右、上下关系。空间位置的体现常常不清楚，我是用穿过每个物象的落点（坐落在台面）的前后水平线来标示的。起稿的过程就是了解物象的结构和在纸上搭建这组合结构的过程。

至于画圆柱体起稿时要作中线，画水果要找到中轴线的基本原则是任何教科书都会明说的。

右边的图层清楚地呈现出我作画的步骤：通常，我是从暗部着手，先画大片色。以这幅画来说，背景就是在暗部铺完后接着画上的。因为色粉在作画过程中会有一部分掉落下来，所以，先画上面的背景，而且要画得薄一些，这很有必要。

Still Life Study

It can be challenging for a beginner in pastel to work on portraits and figurative paintings. I suggest starting with still life. It gives you the time you need to get familiarized with the properties and qualities of pastel.

This page outlines the process of creating a still life painting. The image on the left shows the starting sketch. I pay attention to the composition, which by my definition, is to "cut" what you see, arrange it on paper with a clear focal point and create a balanced and harmonious rendering of the objects in a way that appeals to you. You should concentrate on a few things: the shapes of the objects, the proportions of the objects in relation to each other, and the spatial relationships between the objects, both horizontally and vertically. It can be difficult to capture the spatial relationships. To overcome this, I imagine horizontal lines that cross through each of the object at the point where it is attached to the table, and then compare all the horizontal lines to determine which object should be painted closer to me and the others farther away from me. The purpose of the sketch is to understand the structure of the objects and to recreate that structure on paper.

More details on creating a sketch are covered in many textbooks on drawing. For example, you need to draw an axis for a cylinder and therefore for the fruits in this particular still life.

The image on the right shows the steps I usually take for block-in. I usually begin by working with the dark areas. I work from top to bottom and from large to small areas. Taking this painting for example, I block in on the background immediately after working on the darkest areas. When working with pastel, it is inevitable that some of the color powder will fall off. So I advise you to paint the background before working on the objects. Of course, the background needs to be painted with only a thin layer of colors.

静物《有提把的陶罐和水果》过程图解

　　先画静物，对尚不熟悉粉彩材具的人来说十分必要。在画静物的过程中可以了解粉彩纸与色条的关系：其色粉与纸之间没有水彩中的胶质或油彩中的油质做连接附着媒介物，因而较易掉落。色棒是短条状，因而作画呈现的形态是线条状或横卧涂出的短片状。想要更柔和细致的色层变化就需要糅合。糅合的办法通常是用手指，也可用纸笔，但纸笔常常会把底子填抹得平滑不透气，因此不宜多用。

　　过去用粉彩纸，粉易脱落，所以画作线状的面貌较普遍。但用砂卡纸或砂卡板就好多了，可以多次上色，不易脱落。当然，过多涂抹也会脱落的。

　　中间的图中有一芒果，我嫌它太红、太抢眼，就填掉了。改之前，我用木工细砂纸剪成细片轻轻地将芒果色磨松吹掉，然后再上色。在画有芒果的位置上尚有些原来的色粉残留。拿掉芒果后将水果位置稍加调整。

Still Life: *The Clay Pot and the Fruits* in Stages

　　It is essential for beginners to paint still lifes to familiarize themselves with pastel. You will get to know the relationship between the paper and the pastel crayons during the process. The pastel powder tends to fall off very easily because there is no medium to facilitate attachment to the paper. In watercolor pigments, the glue functions as the medium; in oil pigments, the oil serves this function. Since pastel crayons are usually short, you can paint with the side of the chalk to create small patches of color in addition to drawing lines with the tip of the chalk. Blend the colors with your fingers to create a softer effect. You can also use a paper stump, but use it sparingly to leave some "breathing room". Do not create a surface that is so smooth and flat that it becomes dull and lifeless.

　　When I first began painting pastel, I painted on paper. So I would paint simple lines rather than color patches to prevent the powder from falling. Once I switched to sand paper and sand boards, I enjoyed more freedom to paint multiple layers. Of course there is still a limit to the number of layers you can apply since the powder will still fall off if the surface becomes too smooth.

　　Noticing the mango in the center of the second image. I removed the mango in the later stages because its color came off too strong, thus creating a disharmony. Here is how to remove the color powder. I cut a piece of fine sand paper into small pieces and use them to rub off the powder. Then I blowed away the excess powder and paint the area with new colors. In the third image, you can see some remaining colors of the mango. I adjusted the positions of the other fruits for balance after removing the mango.

有提把的陶罐和水果 (1) The Clay Pot and the Fruits (1)

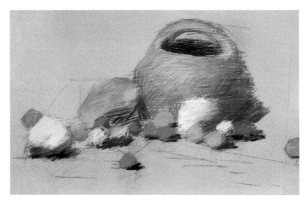

有提把的陶罐和水果 (2) The Clay Pot and the Fruits (2)

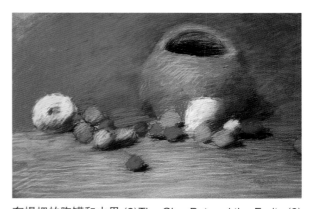

有提把的陶罐和水果 (3) The Clay Pot and the Fruits (3)

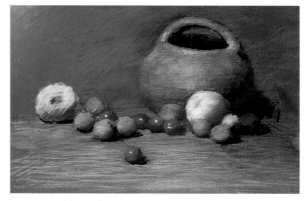

有提把的陶罐和水果 (4) The Clay Pot and the Fruits (4)

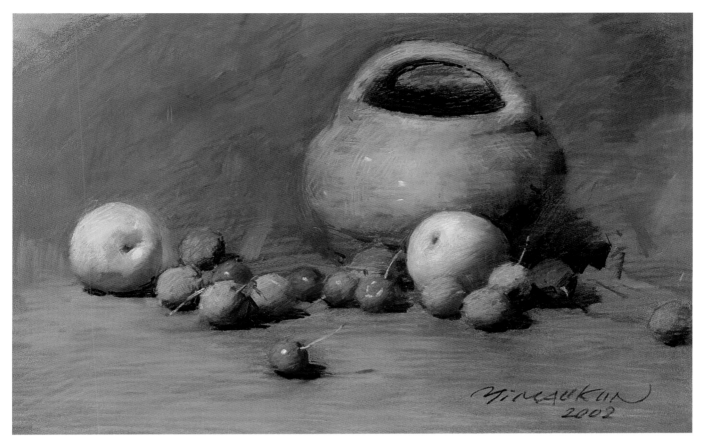

有提把的陶罐和水果
50 cm × 65 cm
2002・台北

The Clay Pot and the Fruits
50 cm × 65 cm
2002・Taipei

　　粉彩具有相当的表现力。它可以将色层铺叙得十分细腻，也可将细节刻画得很精致，几乎可以表现任何物体的质感，画中的细节不必像水彩那样要预先留空下来（如常见的"高光"预留）。粉彩中的高光等细节可以最后加上去，如画中樱桃的高光和细柄。

　　这些画作几乎都是与学生同步作业的示范作品，有时会有画得太细致的毛病。不过，说实话，画写实画常常会忘乎所以地直追下去，最后效果往往显得画过了头，太真实其实不是优点。真实，是写实画的要点，艺术的真实才是写实画的真谛。

　　Pastel is truly a versatile and expressive medium. It is not only great for rendering soft and subtle colors, but also suitable for depicting the finest details. It can convey the feel of any texture and material. You do not need to reserve painting on the lightest areas until the last stage (in contrast to oil painting, where you need to reserve the area for the highlight). You can simply add the highlights and other light colors at the last minute, which is what I did with the highlights on the cherries and the stems shown here.

　　Most of the paintings printed in this book were created in class while my students were working on their paintings. Sometimes, I got stuck in painting too many details. In realistic painting, it is very easy to get stuck in capturing all the details that nature has to offer. The result? A painting that looks like a facsimile of the object. In realistic painting, although it is important that you represent the object realistically, what is more important is to create a painting of high aesthetic value.

静物《水蜜桃、瓷罐和红樱桃》

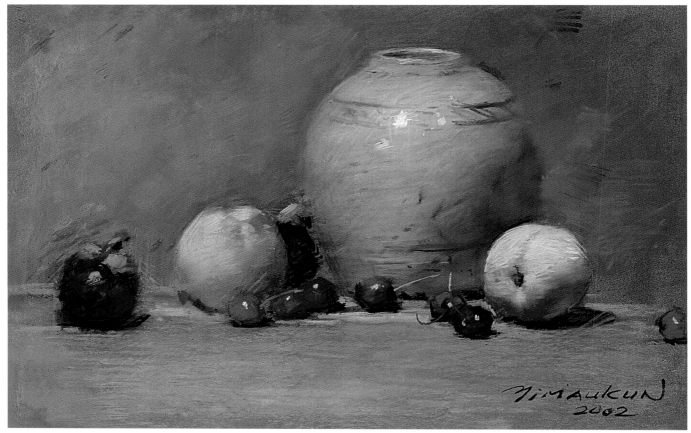

水蜜桃、瓷罐和红樱桃
33 cm × 50 cm
2002・台北

Peaches, the Porcelain Pot and Cherries
33 cm × 50 cm
2002・Taipei

　　画到这张静物时，我自己颇有些体会了。手更轻了，色彩的演变更细微更柔和。其实，我在画面上作画的时间不足 4 个小时，因为除了示范、讲解，在两堂课共 6 个小时的上课时间内，我还要对近 20 名学员的画面进行指导。

　　粉彩的特色是色彩的丰富、细微和柔和，粗犷、坚硬不是它的特色。水彩可以很流动，油画可以很厚实。但粉彩很难模仿水彩的流畅，因为它没有水；粉彩也不如油画厚重，因为色粉不能堆砌。可粉彩有别样的温柔和细语，这是它特别受到大众喜爱的最重要的原因。

Still Life: *Peaches, the Porcelain Pot and Cherries*

　　At the time when I was painting this still life, I had become more familiar with pastel and felt more comfortable maneuvering the tools. I had a better command on how much weight to put on the crayons, and I was able to create softer colors rich in nuances. Even though I had a total of six hours in the two class sessions, I had to spend approximately two hours on demonstration, as well as lecturing and instructing 20 students. The total time I spent working on this painting did not exceed four hours.

　　The strengths of pastel lie in its richness, softness and elegance. It is by no means a hard and rough medium. Watercolors flow beautifully, and oils are thick and solid. Pastel lacks the flow in watercolors or the thickness in oils. Nevertheless, pastel speaks a uniquely tender language that accounts for its popularity.

静物《维纳斯小雕像、书本与红烛》过程图解

从这4幅连环画幅中，我们可以明了作画过程。

第一幅图不用说了，第二幅图是上色的铺色阶段，我常常是将大色块大关系约摸地画上，小的造型上、色彩上的变化忽略不计。

从第三、第四幅图可看出我已从"维纳斯"石膏像的头部开始加工细部，其中，用了手指的揉擦。

这尊小石膏像是我20世纪80年代初从广州美术学院雕塑系买得，辗转带到台北，可惜在一次地震中摔破了。

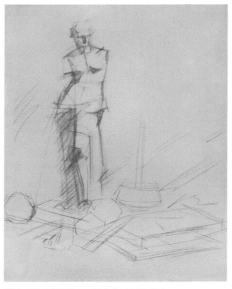

维纳斯小雕像、书本与红烛 (1)
Venus, Books and the Red Candle(1)

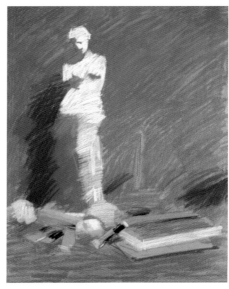

维纳斯小雕像、书本与红烛 (2)
Venus, Books and the Red Candle(2)

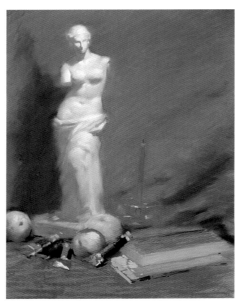

维纳斯小雕像、书本与红烛 (3)
Venus, Books and the Red Candle(3)

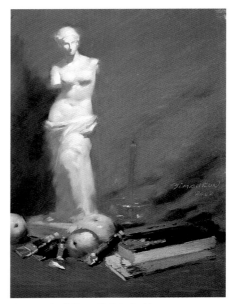

维纳斯小雕像、书本与红烛 (4)
Venus, Books and the Red Candle(4)

Still Life: *Venus, Books and the Red Candle* in Stages

The four images shown on this page demonstrate the process of creating a still life painting.

The first image is, obviously, a sketch of the composition. The second image shows the block-in stage. The trick in this stage is to paint the relationships among and between the large areas of colors and values. Do not concentrate on the details of shapes and colors.

From the third fourth image, you can tell that I start to refine the head of the Venus statue. I blend the colors with my fingers.

This plaster copy of Venus de Milo has been in my collection since the 1980s, when I purchased it from a sculpor at the Guangzhou Academy of Fine Arts. It was damaged in an earthquake a few years ago in Taipei.

头像《红衣男人》过程图解

以下是一幅头像写生的完整过程。

1. 轮廓

打轮廓。所谓轮廓并不是形的外框框,而是要通过画上去的线条将外轮廓及人头的骨骼、体块、五官的比例、形状、透视关系表现出来,并以简略、清晰的线条及深浅做明确的划分。打轮廓的过程就是寻找结构、块面分析、检视比例的过程。

这个轮廓的概念不是平面的、二度空间的。它本身是体积的、三度空间的概念。我的粉彩画打轮廓的方法基本上与我画油画与素描画是一致的。这阶段不必太细节化,但大关系是严格的、严谨的。

我作粉彩人像轮廓用咖啡色(棕色系)较多,有时也用群青等冷色起稿。

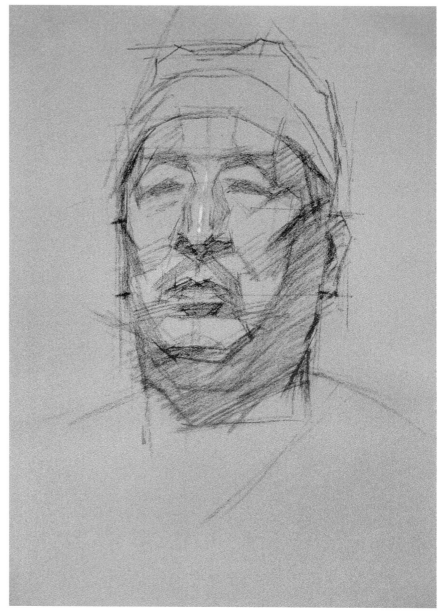

红衣男人 (1)　　　　　　　　　　　　　　　Man in Red Shirt (1)

How to Paint a Head: Step-by-Step

Described below is the process of drawing a head from life.

1.The Sketch

To draw the sketch, it is not advised to outline the boundaries of the head with curving lines. I use straight lines of different angles and lengths to "carve out" the shapes. This renders the facial features, bones, muscles accurately in symmetry and keeps the right perspective. The process of sketching requires you to observe the composition of the face, study the blocks of colors and examine the perspective.

Do not create a two-dimensional sketch. Adopt a three-dimensional viewpoint. My techniques for drawing the sketch of a head in pastel is similar to those in oil and charcoal drawings. It is not necessary to focus on the details at this stage but to focus strictly on capturing the shapes, the overall composition and the structure.

Usually, I use Raw Sienna to draw the sketch. Sometimes I use Ultramarine Deep.

2. 暗部与大色块

　　初学写实绘画的朋友常常缺乏光影的概念，不解明暗之分，常常是勾线后画上一些似是而非的深浅，因而体积感很弱。要知道，在西洋写实画中以明暗呈现体积是最重要的手段，看出深浅层次，看出暗部，尤其要找到明暗交界处，这至关重要。

　　在写生人像中，暗部处于非常重要的地位，它是形体体积的底部，受光部由它托起。找到暗部的形状、它的深浅度和色彩的主要倾向是上色的第一步。通常，人的肤色的暗部色彩偏暖。

　　此像中，为下巴暗部上底色时顺便将红衣领的反光色带了进去。

　　鼻底等处的暗影较深，在这里也与其他肤色的暗处做了区别。

　　接着，将帽与衣的大色块一并画出。

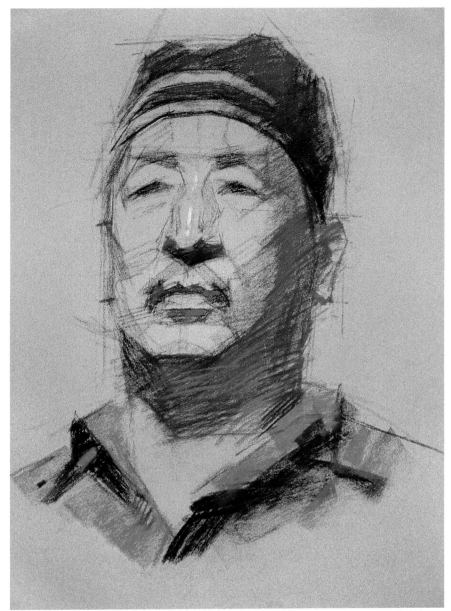

红衣男人 (2)　　　　　　　　　　　　　　　　Man in Red Shirt (2)

2. The Dark Areas and Color Blocks

　　Beginners sometimes have a hard time understanding the importance of light and shadow in realistic paintings. As a result, they create paintings lacking in volume, because they focus too much on drawing the outlines. They cannot distinguish the values that they see, so they fail to pick the right colors when they block in. It is essential to understand that volume is portrayed through the contrast of light and dark. The artist must be able to distinguish the different values and shades and be able to mark the area where dark transitions into light.

　　The dark areas in a live portrait are extremely important. The dark areas are usually at the bottom of the object, and they support the light areas. The first step is to identify the shape of the dark areas, their values and the color tendencies usually the skin tones in the dark areas tend to be warmer.

　　The area of the chin in this image reflects the color of the red collar.

　　The shadows at the bottom of the nose are darker. I make an effort to differentiate them from the other dark areas.

　　Next, fill in the big blocks of colors of the shirt and the hat.

3. 铺色

　　铺大色调是必经过程，我通常不先细画五官，而是在暗部确定后接着画紧邻暗部的中间色域：两颊、鼻的两侧、额的两侧。然后再铺主额、鼻、脸的浅色域和高光。

　　至此，一幅画的大概面貌就出来了，检查一遍，对色彩的深浅和冷暖倾向稍做调整。下一步就可进入细部的刻画了。

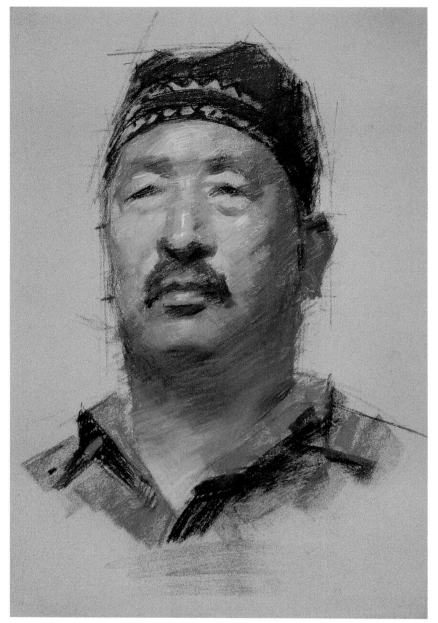

红衣男人 (3)　　　　　　　　　　　　　　　　　Man in Red Shirt (3)

3. Block-in

Blocking-in is a necessary procedure. I usually work in the following order: (1) Tackle the dark areas.(2)Block-in the middle tones immediately adjacent to the dark areas, including the cheeks, the side planes of the nose and the side planes of the forehead. (3) When the dark areas are done, I wrap up by working on the front of the forehead, the light colors and the highlight.

The portrait is almost finished at this point. Review it and make adjustments to accurately depict the light colors. The next step is to paint the details.

4. 深入细绘

　　所谓深入细绘，首先是五官的精确化，其次是色域、色块衔接的具体化。所谓"具体化"是指深浅冷暖和虚实的更细微的变化关系。

　　在加工的过程中，我用手指揉抹，使色域、笔触衔接得自然而柔和些。光揉抹不行，还得酌情加添色彩以补充修正。有时同一个地方就做了三四次。不过，抹太多会过分细柔而"糊"掉，再加色彩就掉粉。这个抹与揉的手法要通过自己试，要反复多画，才能积累经验、掌控得宜。

　　结实的地方，如高光、阴影的边缘较锐利的部分，要再用色条直接补强。

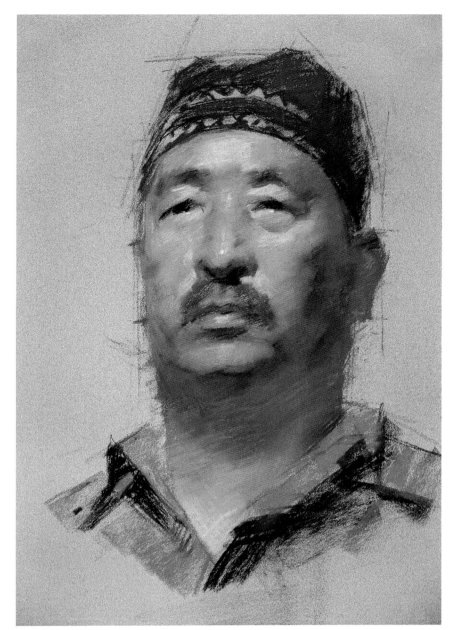

红衣男人 (4)　　　　　　　　　　　Man in Red Shirt (4)

4. The Details

First, concentrate on adding the details of the facial features. Next, concentrate on building contrasts between the dark and light colors, as well as the cool and warm tones. Create soft edges where needed to create illusion of space and transparency.

In this step, I blend the colors extensively with my fingers in order to make the color patches and strokes appear natural and smooth. Sometimes I need to add in colors to accurately reflect what I see. It can take up to three or four tries to get it right. You need to be careful not to "over-blend" the colors, making the surface too smooth to retain the color powder. The best way to learn blending is through experiment. Through trial and error, you will learn the most effective way to blend.

Finally, strengthen the solid areas. Pay special attention to the highlight and the edges of the cast shadow. Do not blend the colors because these areas need to appear sharp.

5. 调整、结束画面

　　结束画面这个阶段也十分重要。从画面中可以看到我加工了帽子的花边，也铺开了红衬衣，尤其重要的是补充了脸颊暗部的冷色的反光。

　　画人物头像时，初学者认为五官、肤色很难处理，我却认为额、颧、脸颊的两边是最难处理的：要怎样表现出透视压缩薄了的面，而色彩又能反映环境色的影响，同时符合整体的色彩、形体的感受？还有，难以决断的所谓细节的"细"，要细到何种程度？过分细腻会掉入照片化的陷阱，粉彩其实也很容易掉入过细的陷阱。

　　啊，细节，最难拿捏。

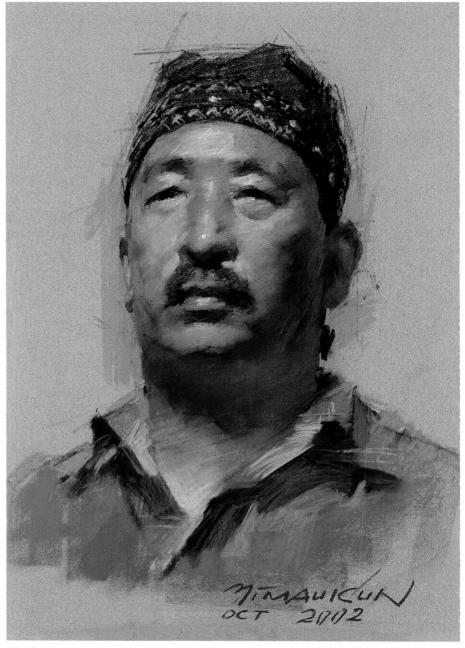

红衣男人 (5)　　　　　　　　　　　　　　　　Man in Red Shirt (5)

5. Final Adjustments

　　These final steps are also very important. I complete the details of the hat and the red shirt. More importantly, I add the reflections of the cool tones in the dark areas of the cheeks.

　　Most beginners find it difficult to paint the facial features and the skin colors. I think the most difficult areas are the side planes of the forehead and the cheeks. I ask myself the following questions when I work on these features: How do I paint the far side of the face in the right perspective? How do I reflect the surrounding colors in the skin tones? What can I do to make sure these colors are harmonious with the overall ambience? Also, how many of the details should I paint? If I paint too many details, the painting would look like a photograph rather than a painting. When working with pastel, you need to be careful not to fall into the trap of painting too many details.

人像《染发女子》过程图解

4张人物写生的过程放在一起可以让人对步骤的面貌一目了然。

两堂课共6个小时，扣除模特休息时间，在画面上作画的时间少于4个小时，也够了。

这幅画强调了体块的概念，在铺画脸的暗部时是将色条横着抹上去的。在亮部铺完后再画冷暖变化。

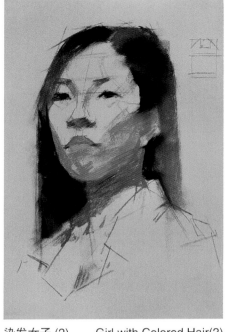

染发女子 (1)　　Girl with Colored Hair(1)　　染发女子 (2)　　Girl with Colored Hair(2)

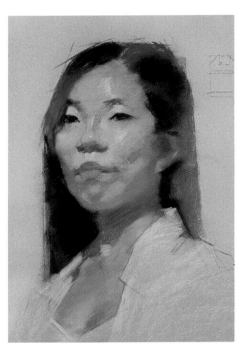
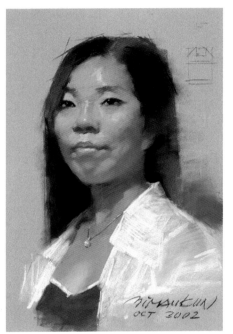

染发女子 (3)　　Girl with Colored Hair(3)　　染发女子 (4)　　Girl with Colored Hair(4)

Portrait: *Girl with Colored Hair* in Stages

These four images illustrate the steps of creating a portrait from life.

I created this painting within two class sessions. Since the sitter needed breaks every twenty minutes or so, the total time for painting was less than four hours, which was enough.

I used the technique of mass block-in in this painting. When working on the dark areas of the face, I paint with the side of the chalk. Then I worked on the light areas. Finally, I made finer adjustments to reflect the color temperatures.

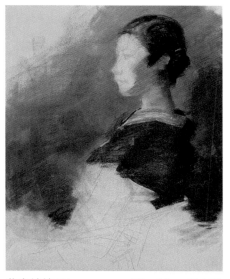

苗家姑娘 (1)　　The Miao Girl (1)

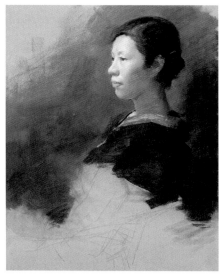

苗家姑娘 (2)　　The Miao Girl (2)

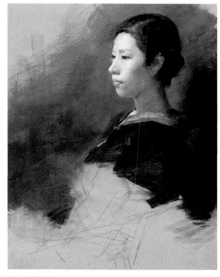

苗家姑娘 (3)　　The Miao Girl (3)

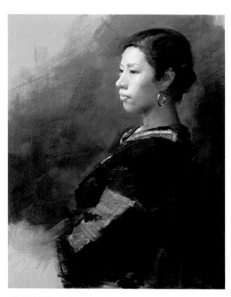

苗家姑娘 (4)　　The Miao Girl(4)

人像《苗家姑娘》过程图解

这是《苗家姑娘》的连续画面，是我绘制大幅粉彩人物肖像的典型过程：轮廓确定之后，从头部的暗部开始铺色，然后到衣服（身躯），再到背景，接下来到脸的亮部和五官，从上到下逐步深入描绘……最后做形体、色彩、虚实、细节、笔触的调整，结束全画。

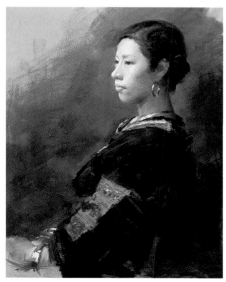

苗家姑娘 (5)　　The Miao Girl(5)

Portrait: *The Miao Girl* in Stages

The images demonstrate the process of creating The Miao Girl. It shows the typical procedures I take when painting large scale portraits in pastel. (1) Create a sketch. (2) Block in the dark areas-begin from the head, move to the clothes (the bust) and finally to the background. (3) Paint the details-begin from the light areas of the face including the facial features, and then move down the body to work on the sleeves. (4) Finally, make adjustments on the shapes, colors, edges, brush strokes and other details.

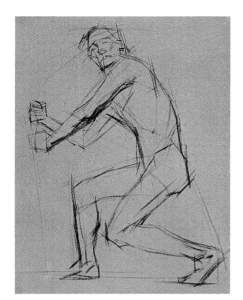

挂杖男子 (1)　　　Man Holding a Stick(1)

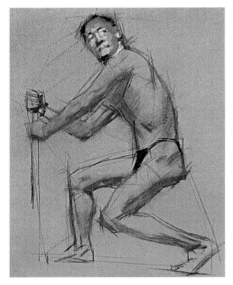

挂杖男子 (2)　　　Man Holding a Stick(2)

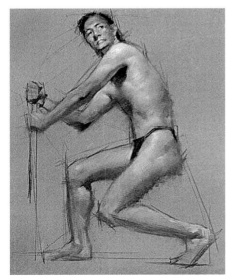

挂杖男子 (3)　　　Man Holding a Stick(3)

人体《挂杖男子》过程图解

　　人体一样可以作为粉彩描绘的题材。画人体牵涉到人体骨骼、肌肉的解剖知识。这些应该在素描练习中解决，在此不做细述。

　　首先是动态和比例。注意股骨与胫骨的长度比例、肱骨与前臂的长度比例，同时留意前后透视的变化。把骨骼关节和主要外显肌肉标示出来。注意躯干与头的造型和动态。

　　再以褐色将暗部涂抹出来，顺便用手指揉抹出中间调子。

　　铺色至亮部，注意头、躯干、四肢基本色块的区别（指深与浅、冷与暖的区别），标示出最亮处（左肩）、次亮处（髋关节）等。

Figurative: *Man Holding a Stick* in Stages

　　The human body is also a good subject for pastel paintings. To paint the figure accurately, you need to acquire anatomical knowledge of the human bones and muscles. If you do not have basic understanding in these areas, you can find the information in related drawing textbooks.

　　First, pay attention to the man's movement and proportions of the body. Notice the proportions of the femur, tibia and fibula, as well as the proportions of the humerus, ulna and radius. You need to observe the foreshortening perspective. I suggest you mentally label the joints and the most important muscles. You need to also pay attention to the movement of the torso and the head.

　　Block in the dark areas with Transparent Oxide Brown and create half tones, blending with your fingers.

　　Block in the light areas. Pay attention to the values (the range between lightness and darkness, cool and warm temperatures) in the different areas between the head, torso and limbs. Mark the highlight (the left shoulder), and the area of the pelvis, which is next in the degree of lightness.

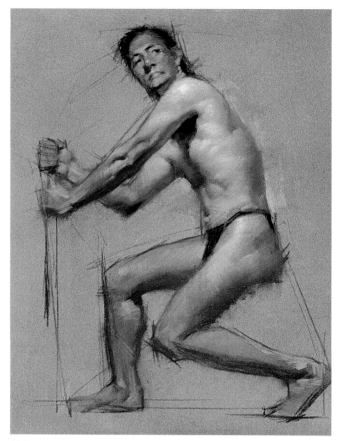

拄杖男子 (4)　　　　　　　　　　　Man Holding a Stick (4)

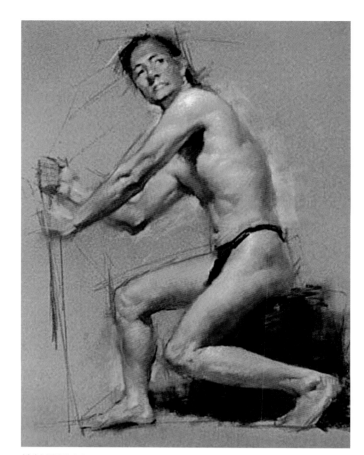

拄杖男子 (5)　　　　　　　　　　　Man Holding a Stick (5)

　　将人体从头开始，由上而下做一次较深入的细节刻
画，并重新调整色彩和笔触。最后，画上坐凳布色，即
完成此图。

　　这是一张浅灰黄绿的砂卡纸。由于作画时间只有近
4 个小时，背景色调只好省略。

　　顺便提一提，画中模特是我的高雄绘画研习班班长
蔡文生先生。他原是当地杰出的电机维修技师，热衷绘
画，从不放弃，坚持下来终于成了专业画家，并开设画
室教学兼创作。他改变职业等于翻越了一座大山，这需
要巨大的勇气与毅力。

Work on the details from top to bottom. Readjust the colors and
strokes. Finally, paint the color of the cloth on the chair.

The sand paper I used for this painting has a light grayish
yellow and green base color. Due to time limit I had to skip painting
the background.

The sitter is a student of mine who lives in Kaohsiung, the
southern city of Taiwan. He gave up his former career as an elec-
trician to pursue a professional painting career. He now owns
a painting studio and teaches art classes to a large number of
students. His successful transition to a new career is a tremendous
achievement, and I admire him for his courage and persistence.

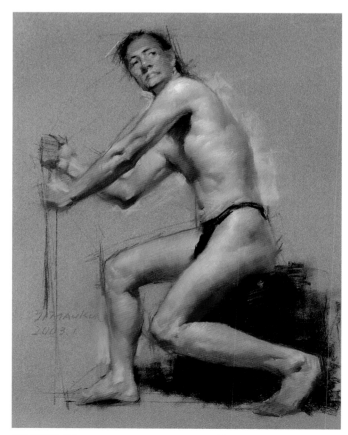

拄杖男子 (6)　　　　　　　　　　　Man Holding a Stick (6)

结语

任何画种都有新鲜感的问题，粉彩画也常会碰到画过头的情况，就是说，在同一地方画得太多，糊了。右图就画得很简洁。

这幅画选用了灰色的砂卡纸，背景用灰蓝粉彩条薄薄地抹画上。其略带粗糙的感觉恰好与细致描绘的花朵形成对比。这是我色粉用得最薄的一张画。一是利用了纸的底色，没有大量叠色覆盖的地方；二是稿起得轻细。

用粉彩画花真是最讨人喜欢了，它可以将花的可爱多姿及多变多彩都生动地呈现出来。我常懊恼抽不出时间来尽情地画几幅瓶花。

以下是作品欣赏部分，同时选择了一些作画过程的画面，其中有些尚称可观，但有少数还显得粗糙。本书既然名为"笔记"，我希望能尽量以摸索中的真实面貌呈现在读者面前，使这本小书能提供多一点点作品以外的图像资讯，以便读者观看时多一层参照，少一点枯燥。

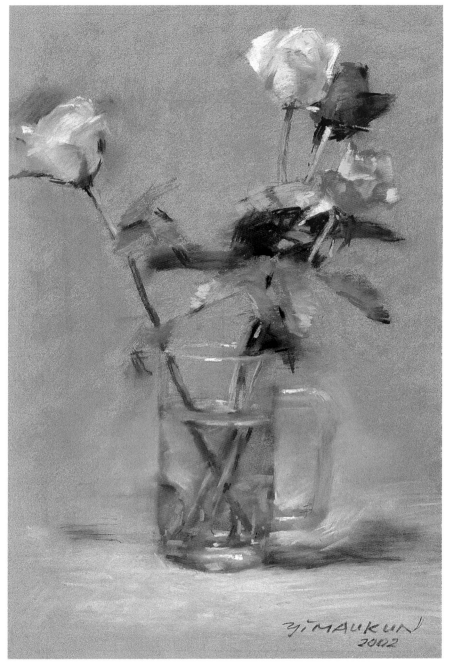

四枝玫瑰 Four Roses

Conclusion

Regardless of the medium you use, be it oil, watercolor, or pastel, it is important to finish a painting "fresh". When you create a pastel painting, make sure not to "overdo" it. Do not paint too many layers in one area lest it becomes too smooth and bland. The painting shown on this page is an example of a painting that offers a simple and elegant finish.

I choose to paint the roses on a piece of sand paper with gray base color. The background is painted with thin hatches of grayish-blue. The slightly rough texture of the background brings forth an interesting contrast against the delicate flowers. In this painting, the powder is painted very thin. In fact, it is the thinnest I have ever painted. Here are my tips: I use a piece of paper with background color, so I do not need to create layers of colors for the background, and I do not put a lot of weight on the crayons when I paint.

Pastel is extremely delightful for painting flowers. It captures vividly the different shapes and colors of the flower petals. I often feel chagrined at not dedicating as much time as I would like to paint more flowers with pastel.

In the following pages, I share pictures of my paintings in stages. Some images show more details than others. I decided to include as many pictures as possible because it is the best way to demonstrate my own learning curve. I hope these pictures are interesting as well as instructional.

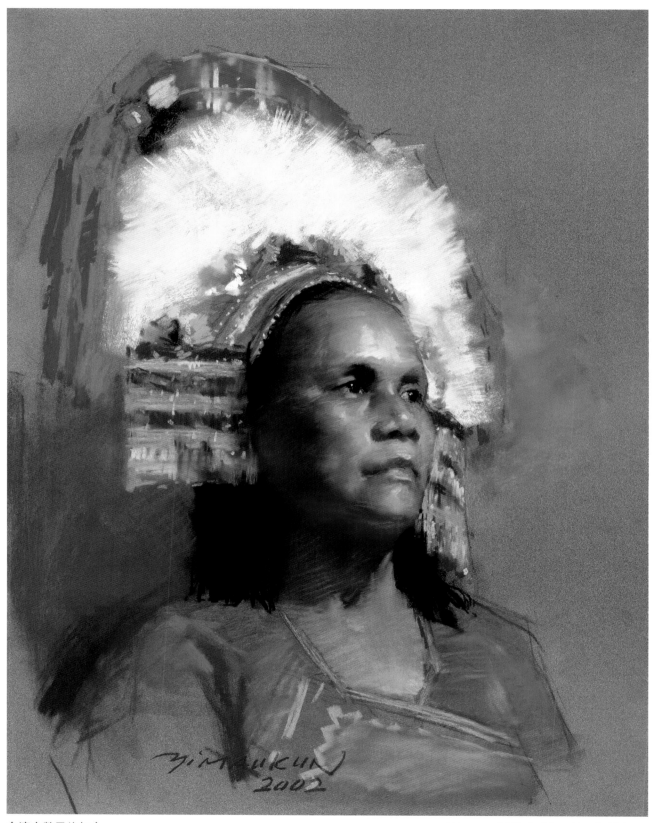

台湾少数民族妇人
65 cm × 50 cm
2002・台北

Woman of Ethnic Minorities in Taiwan
65 cm × 50 cm
2002・Taipei

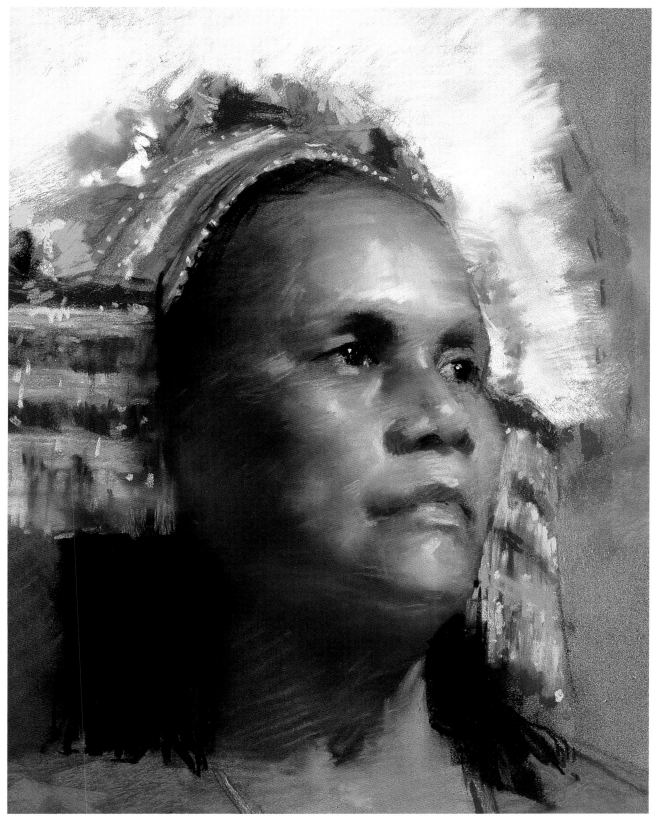

台湾少数民族妇人（局部）

Woman of Ethnic Minorities in Taiwan（portion）

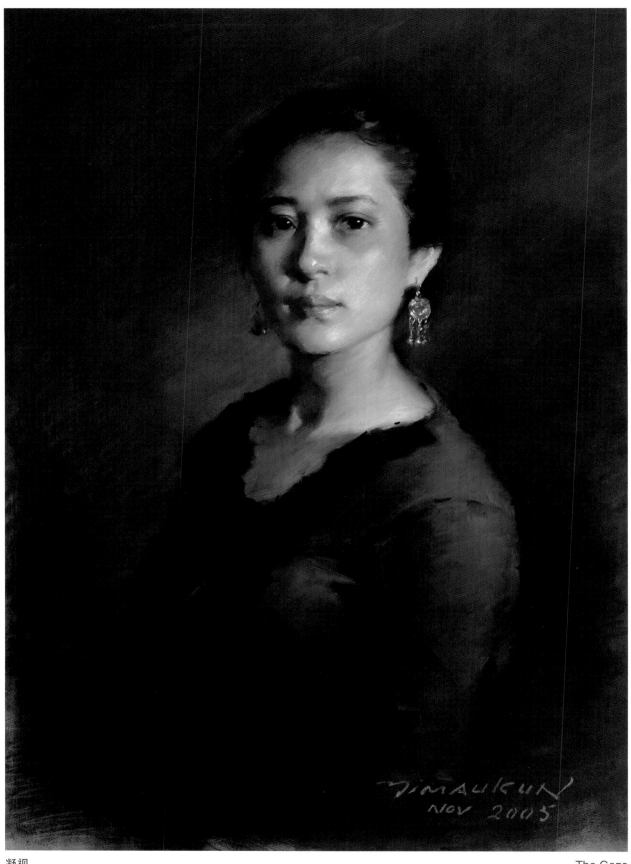

凝视
68 cm × 49 cm
2005・台北

The Gaze
68 cm × 49 cm
2005・Taipei

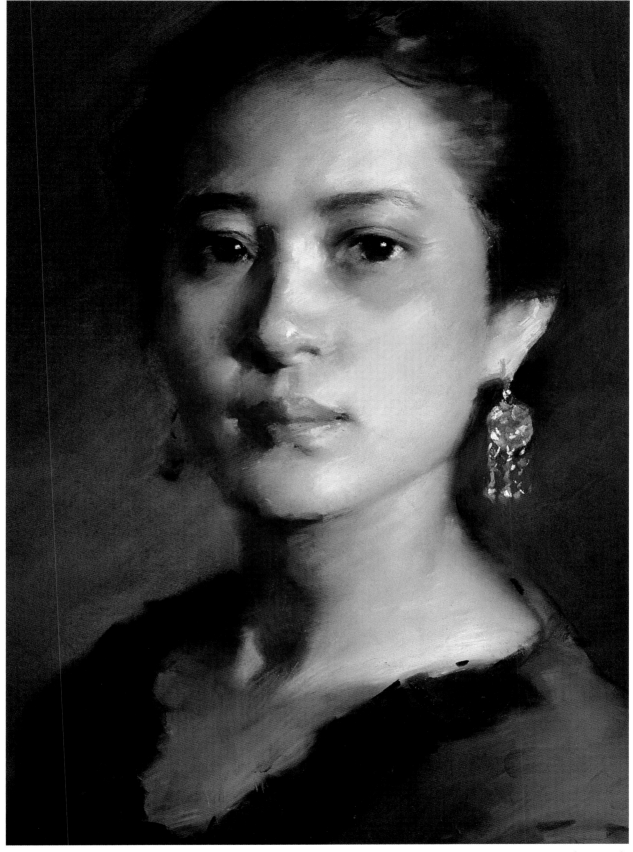

凝视（局部）

The Gaze（portion）

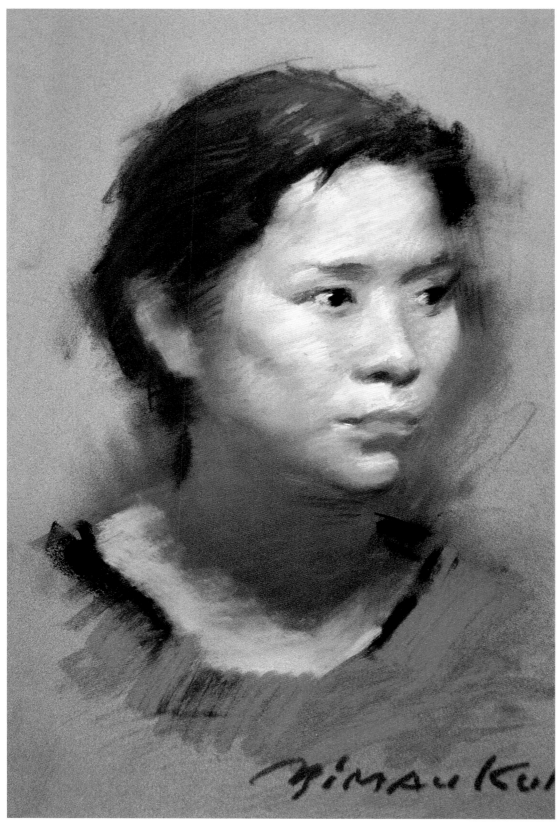

红衣女子
50 cm × 33 cm
2002・台北

Girl in Red Blouse
50 cm × 33 cm
2002・Taipei

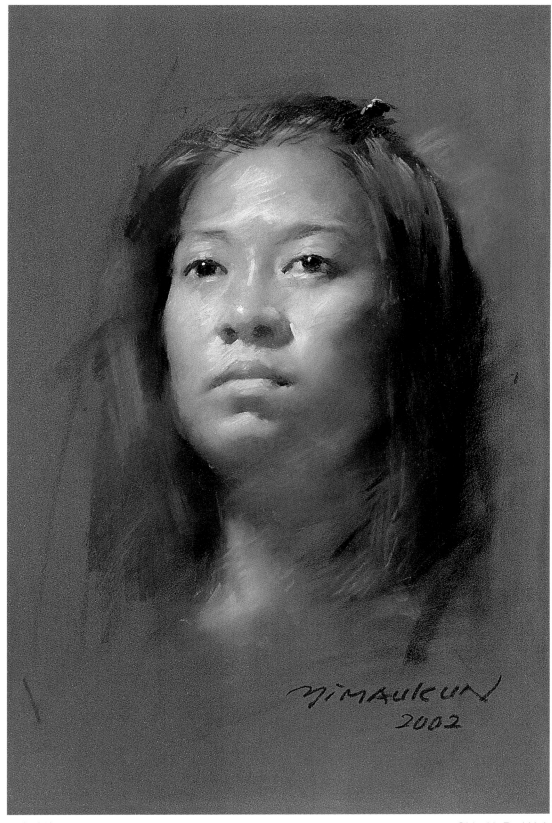

红发姑娘
50 cm × 33 cm
2002·台北

Girl with Red Hair
50 cm × 33 cm
2002·Taipei

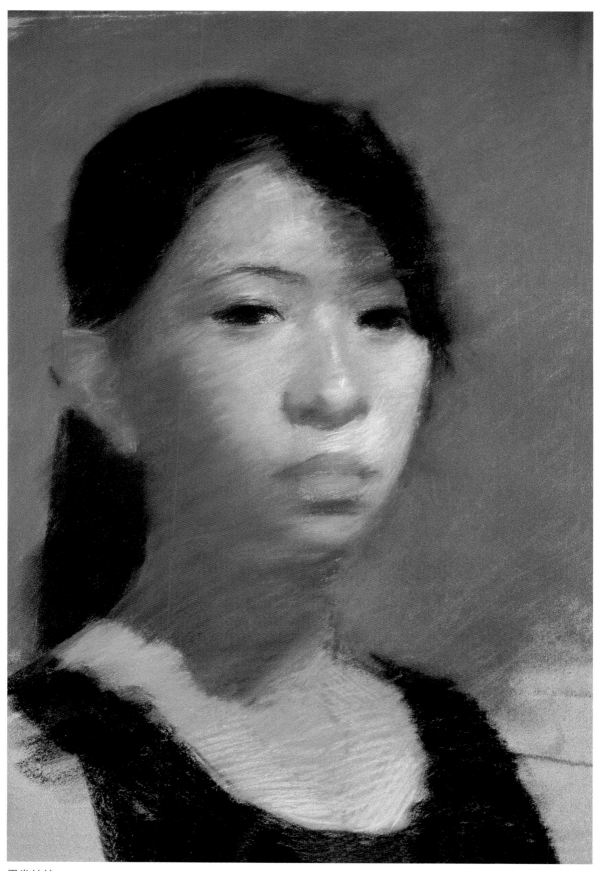

黑发姑娘
50 cm × 33 cm
2002・台北

Girl with Black Hair
50 cm × 33 cm
2002・Taipei

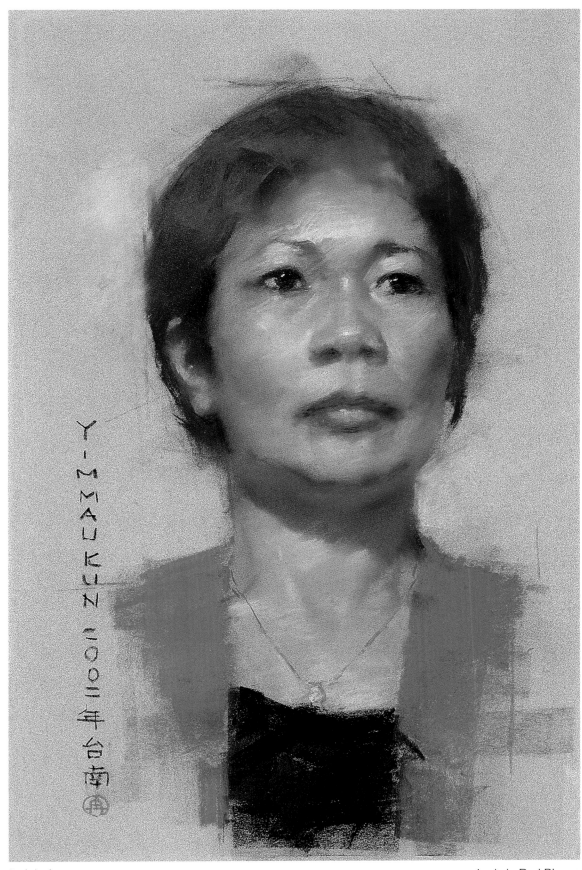

红衣妇人
50 cm × 33 cm
2002・台南

Lady in Red Blouse
50 cm × 33 cm
2002・Tainan

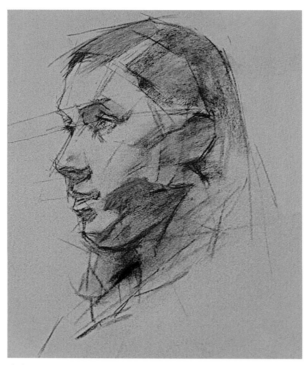

青年画家（未完成图） The Young Artist（unfinished）

青年画家
50 cm × 33 cm
2002 · 高雄
The Young Artist
50 cm × 33 cm
2002 · Kaohsiung

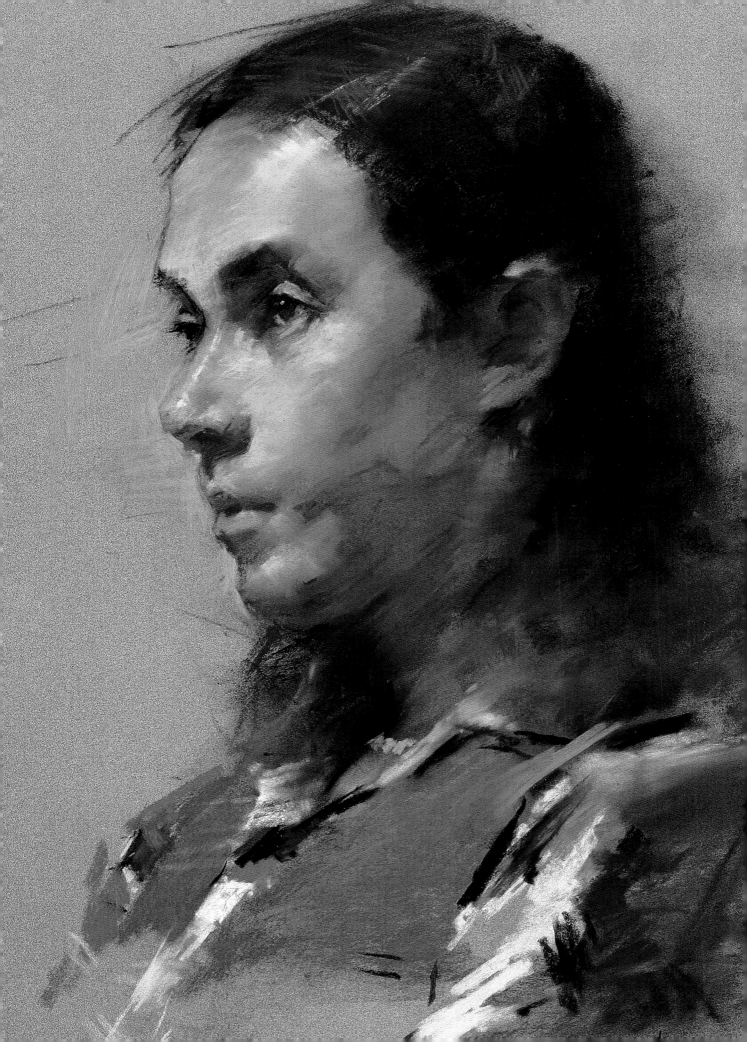

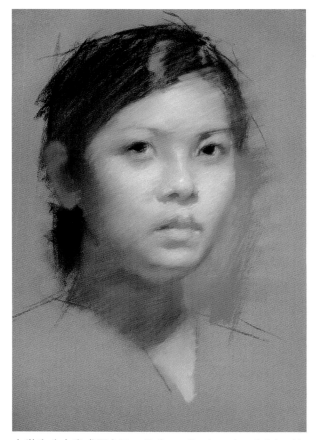

大学生（未完成图）The College Student（unfinished）

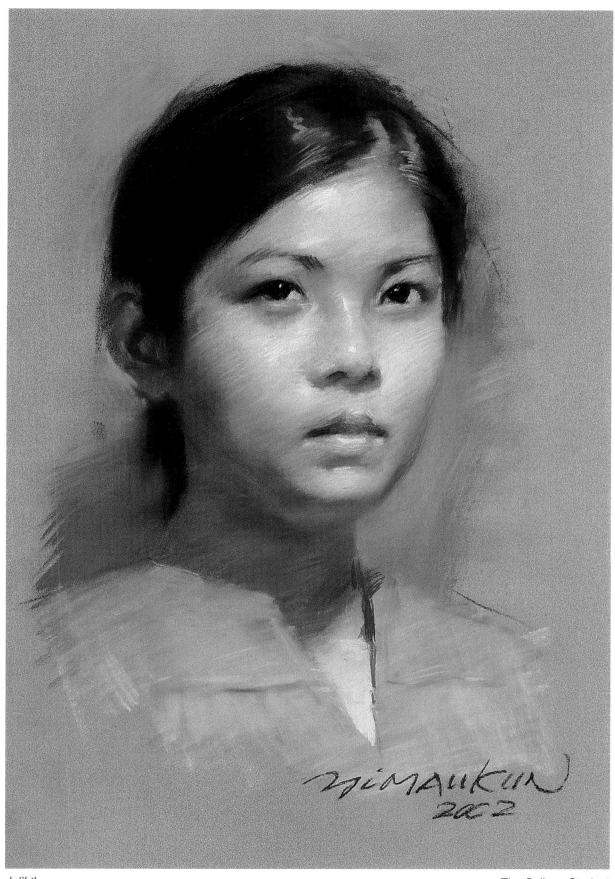

大学生
50 cm × 33 cm
2002・台北

The College Student
50 cm × 33 cm
2002・Taipei

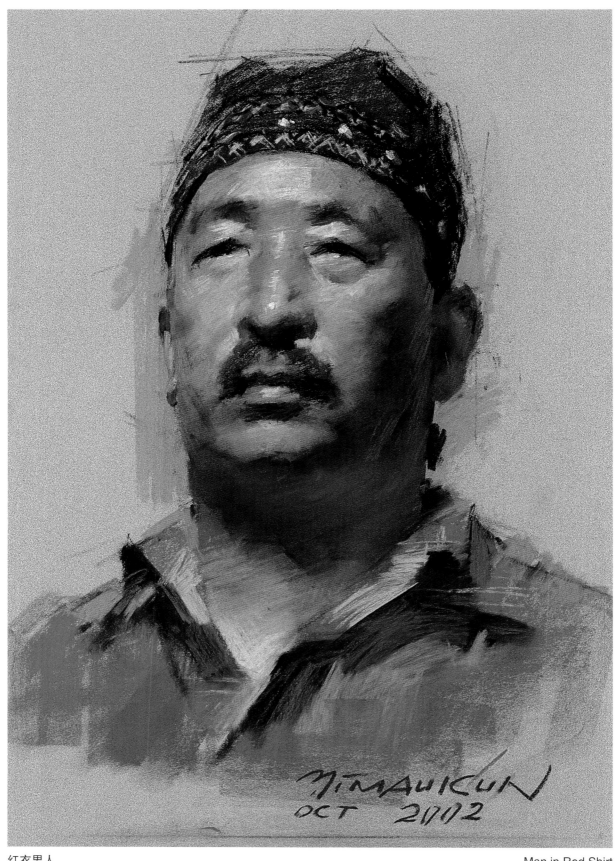

红衣男人
50 cm × 33 cm
2002・高雄

Man in Red Shirt
50 cm × 33 cm
2002・Kaohsiung

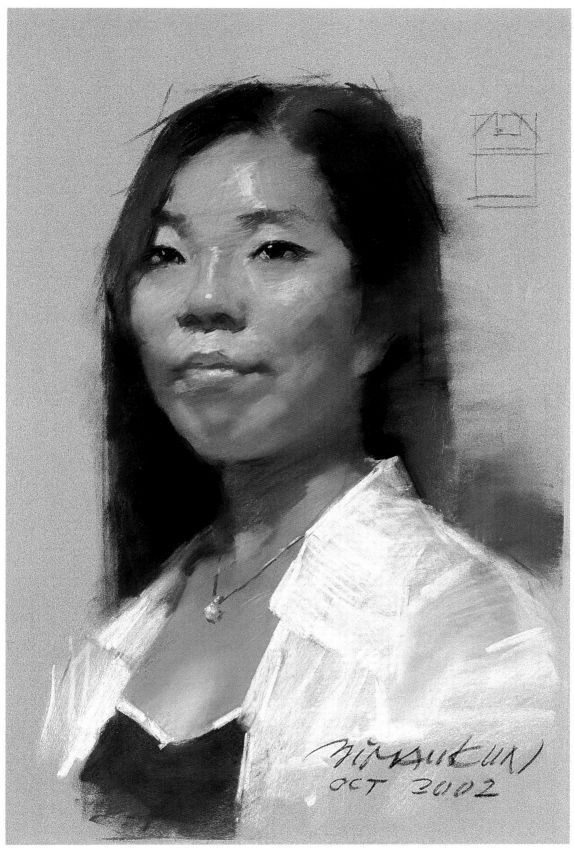

染发女子

50 cm × 33 cm

2002・台南

Girl with Colored Hair

50 cm × 33 cm

2002・Tainan

白发老太太（未完成图） Lady with Gray Hair (unfinished)

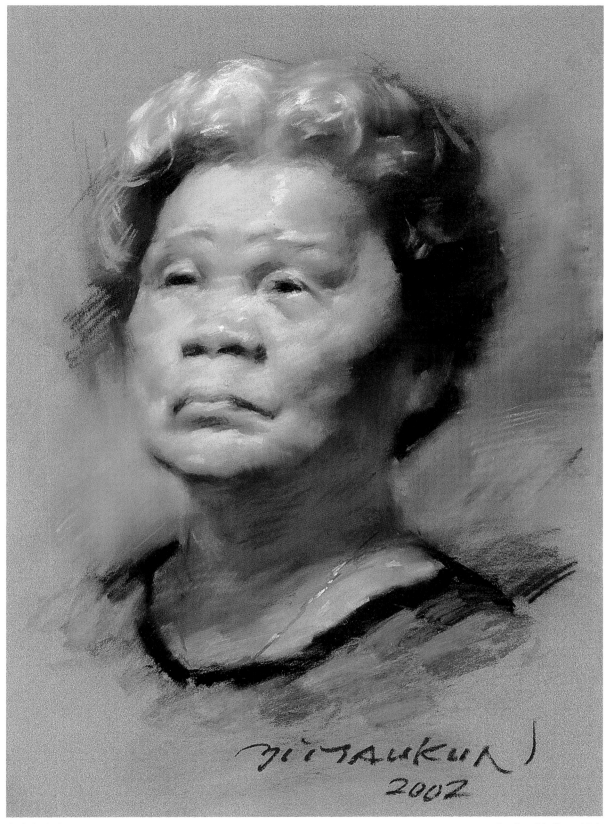

白发老太太
50 cm × 33 cm
2002・台北

Lady with Gray Hair
50 cm × 33 cm
2002・Taipei

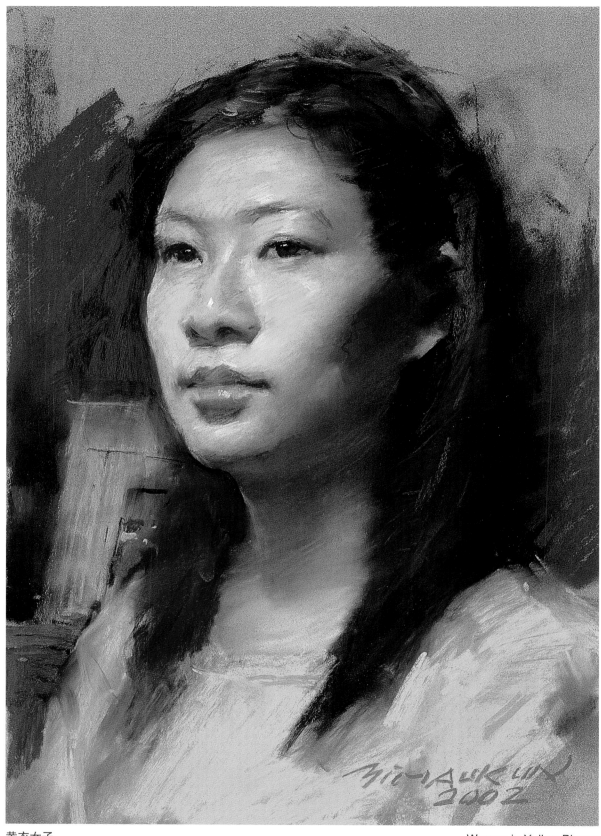

黄衣女子
50 cm × 33 cm
2002・台北

Woman in Yellow Blouse
50 cm × 33 cm
2002・Taipei

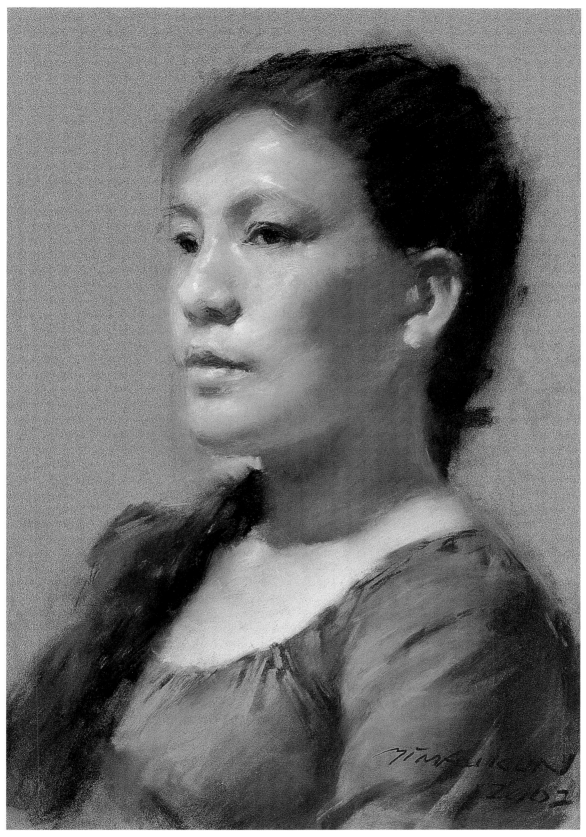

长辫姑娘

50 cm × 33 cm

2002・台北

Girl with long Braid

50 cm × 33 cm

2002・Taipei

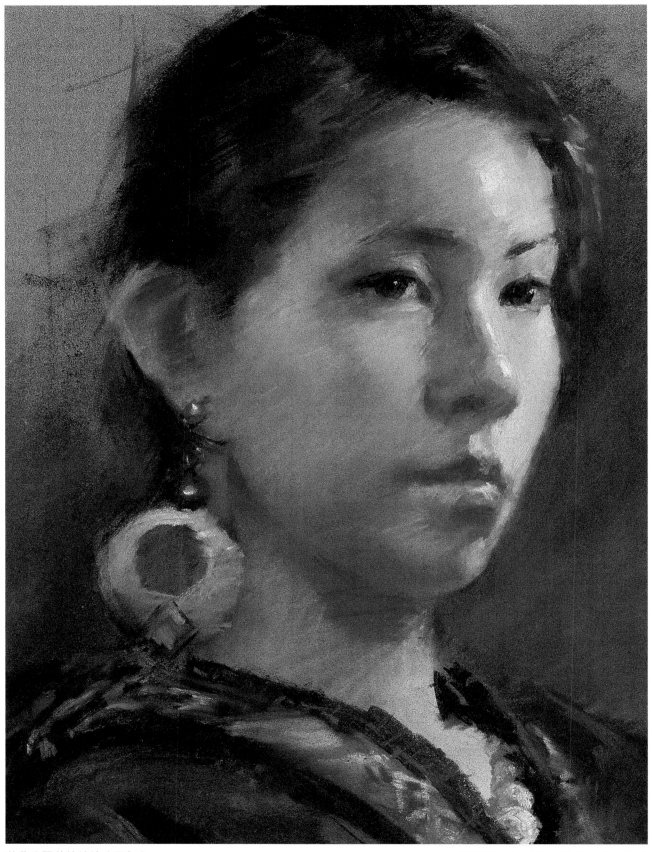

着苗族服装的姑娘（局部）

Girl Wearing Miao Clothes (portion)

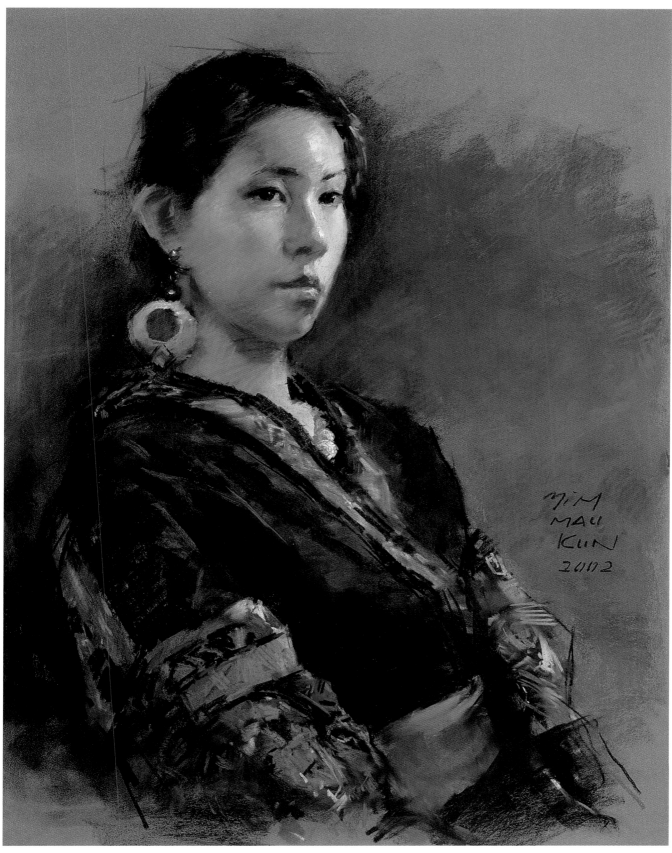

着苗族服装的姑娘
65 cm × 50 cm
2002 · 台北

Girl Wearing Miao Clothes
65 cm × 50 cm
2002 · Taipei

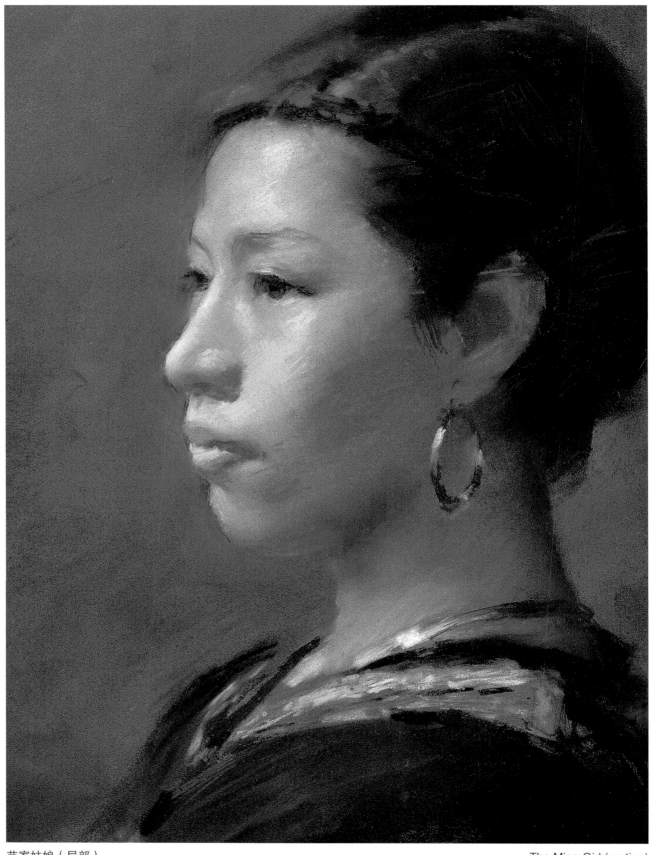

苗家姑娘（局部）

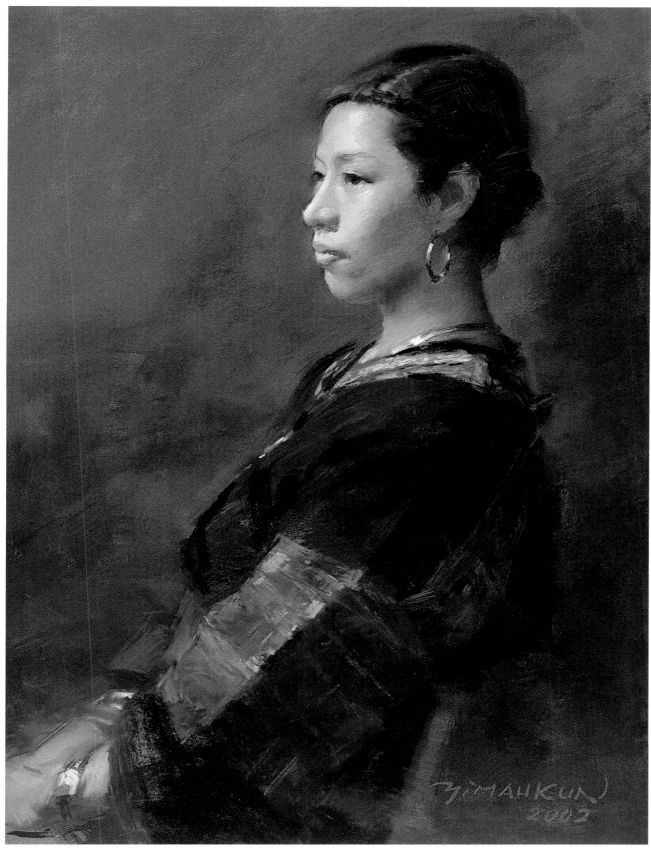

苗家姑娘
65 cm × 50 cm
2002・台北

The Miao Girl
65 cm × 50 cm
2002・Taipei

英文教师（1）　　　　　　The English Teacher (1)

英文教师（2）　　　　　　The English Teacher (2)

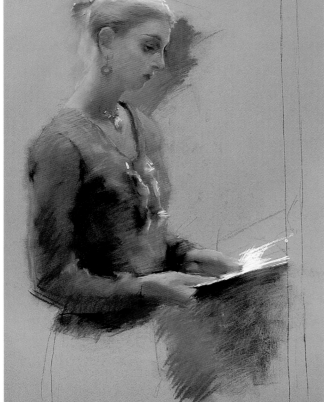

英文教师（3）　　　　　　The English Teacher (3)

英文教师（局部）
The English Teacher (portion)

42

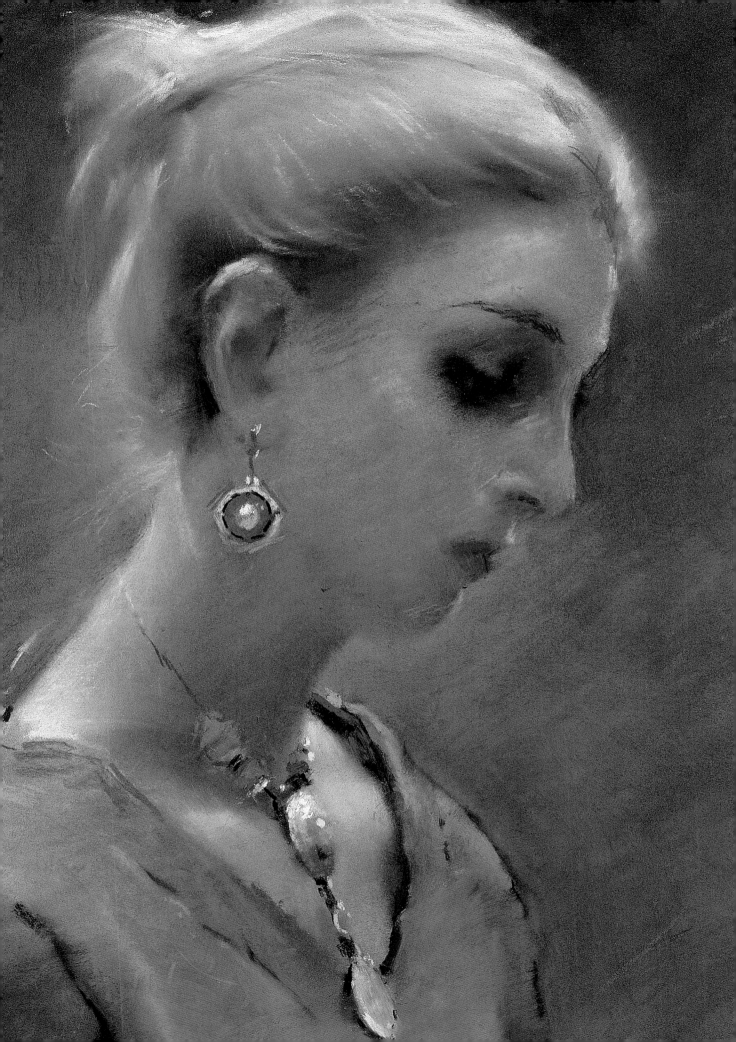

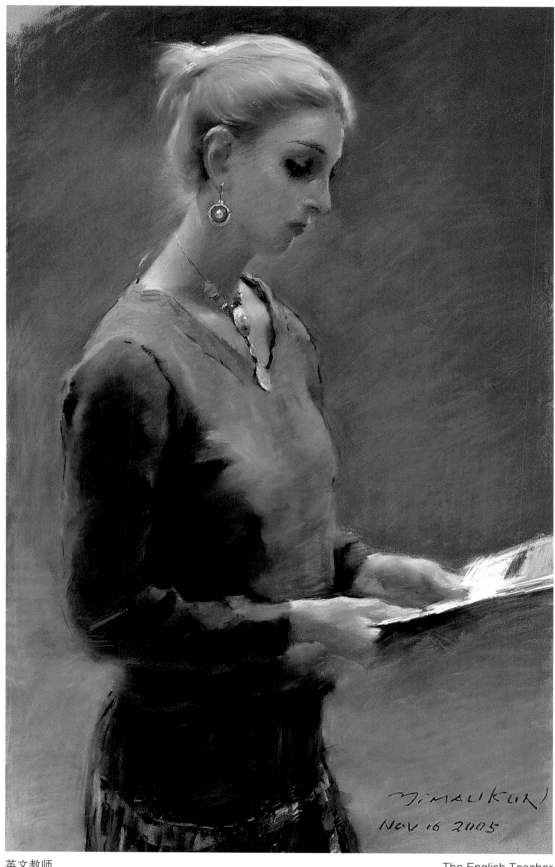

英文教师
80 cm × 48 cm
2005 · 台北

The English Teacher
80 cm × 48 cm
2005 · Taipei

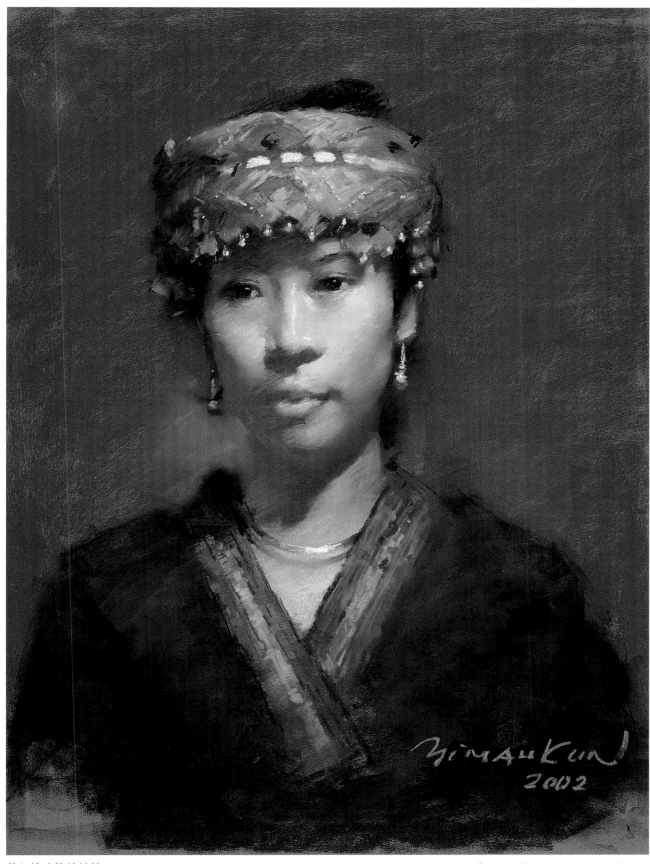

戴织锦头饰的姑娘
65 cm × 50 cm
2002・台北

Girl with Embroidered Headband
65 cm × 50 cm
2002・Taipei

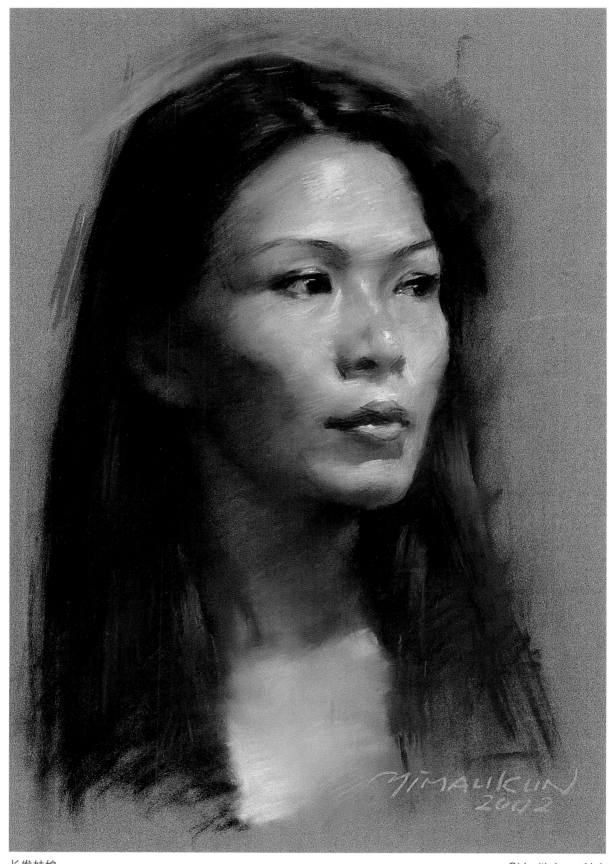

长发姑娘
50 cm × 33 cm
2002 · 台北

Girl with Long Hair
50 cm × 33 cm
2002 · Taipei

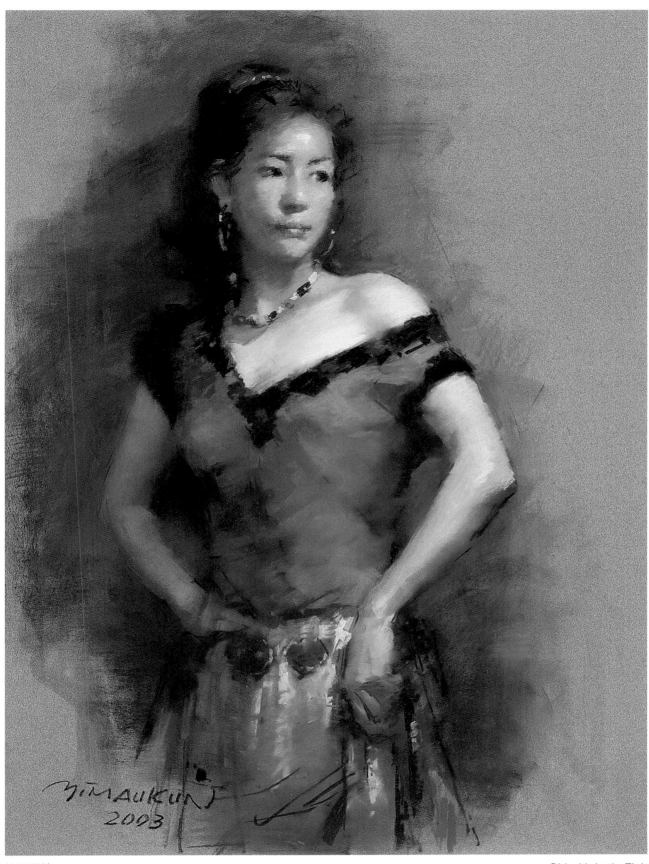

拉丁风情

65 cm × 47 cm

2003・台南

Girl with Latin Flair

65 cm × 47 cm

2003・Tainan

一盘水果（1）
A Plate of Fruits (1)

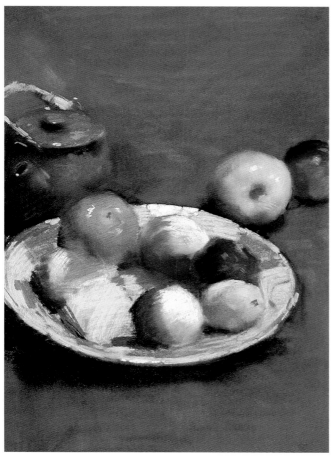

一盘水果（2）
A Plate of Fruits (2)

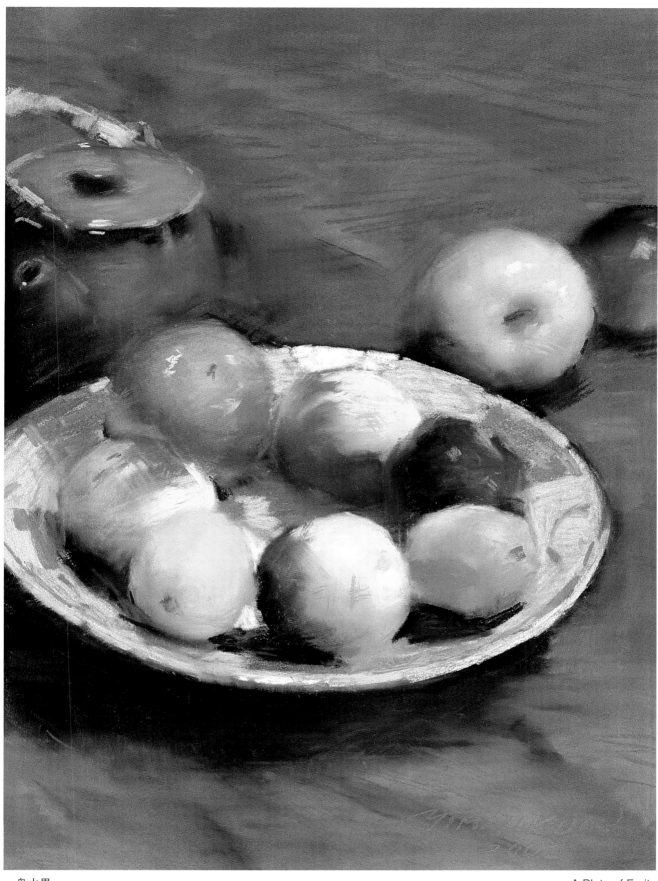

一盘水果
65 cm×50 cm
2002・台北

A Plate of Fruits
65 cm×50 cm
2002・Taipei

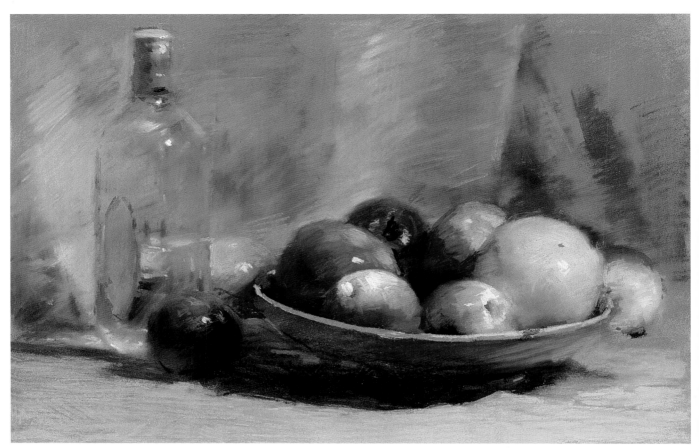

酒瓶盘果
33 cm × 50 cm
2002 · 台北

The Wine Bottle and Fruits
33 cm × 50 cm
2002 · Taipei

一盆兰花
65 cm × 50 cm
2002 · 台北
A Pot of Orchid
65 cm × 50 cm
2002 · Taipei

50

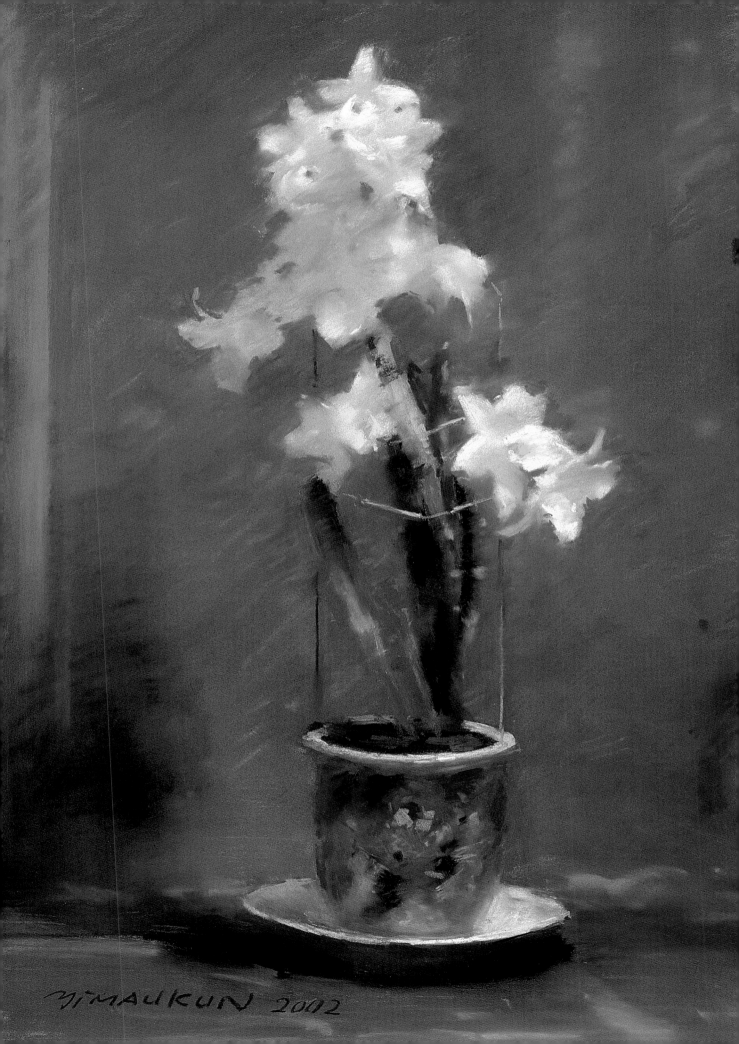

瓶菊（1）
50 cm × 33 cm
2002・高雄
Chrysanthemums(1)
50 cm × 33 cm
2002・Kaohsiung

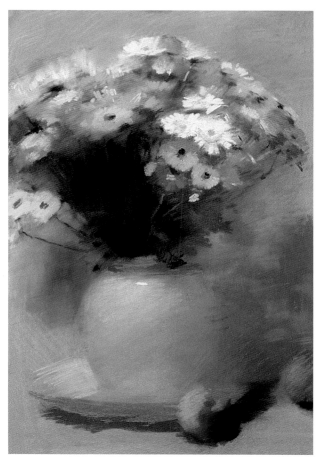

瓶菊（2）
50 cm × 33 cm
2002・高雄
Chrysanthemums(2)
50 cm × 33 cm
2002・Kaohsiung

葡萄红酒
65 cm × 50 cm
2002・台北
Grapes and Wine
65 cm × 50 cm
2002・Taipei

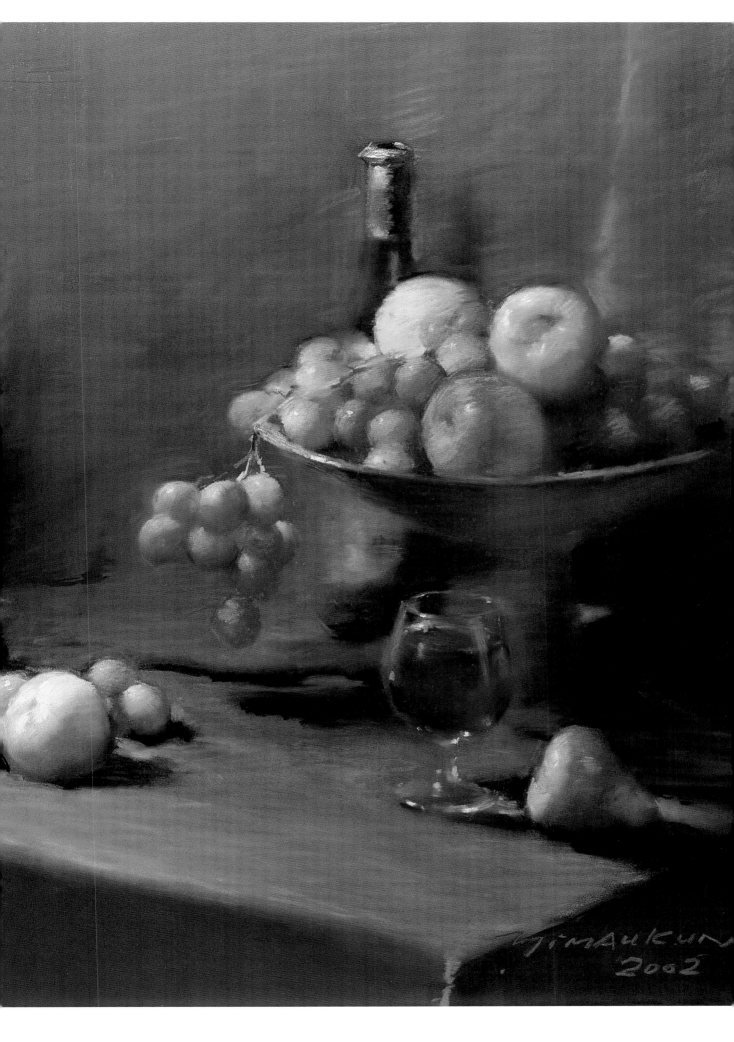

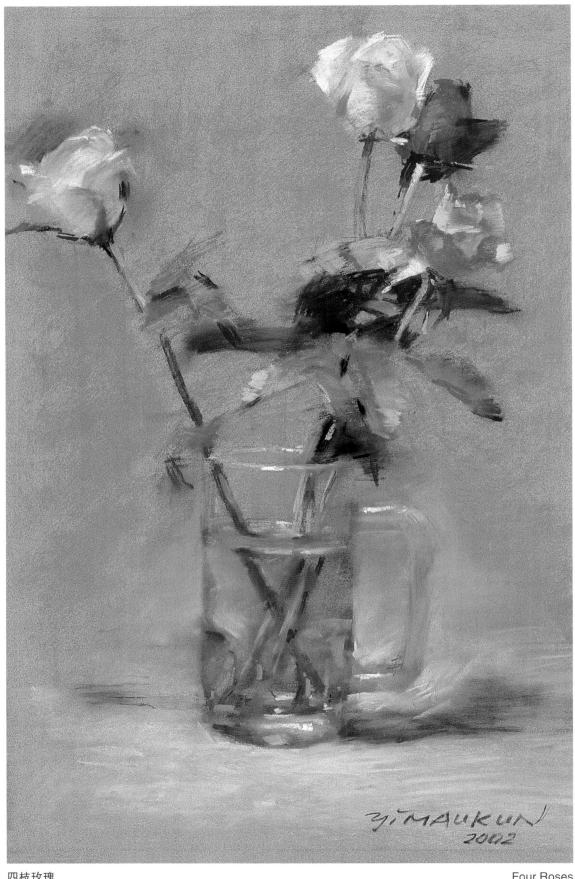

四枝玫瑰

50 cm × 33 cm

2002・高雄

Four Roses

50 cm × 33 cm

2002・Kaohsiung

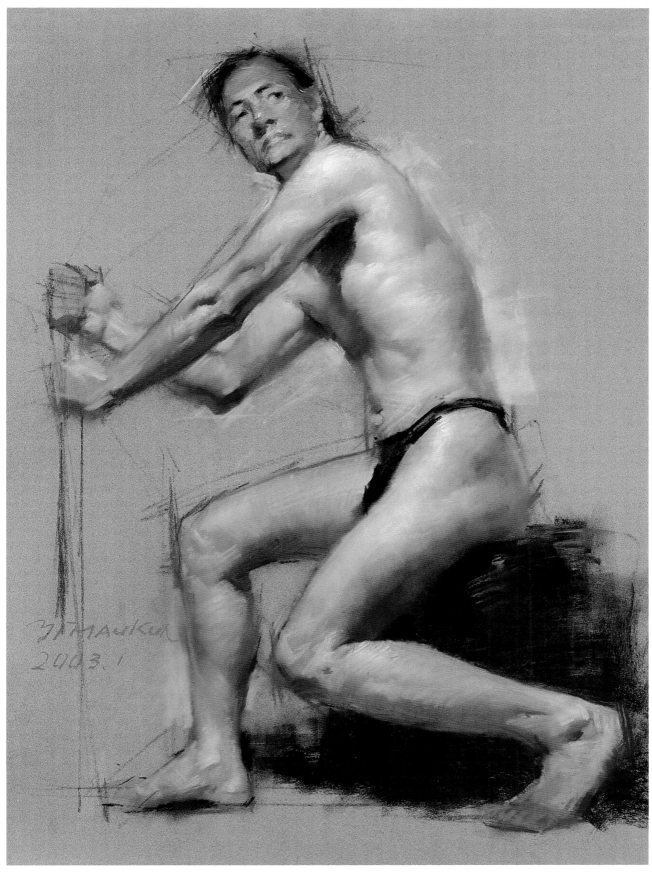

拄杖男子
65 cm × 50 cm
2003・高雄

Man Holding a Stick
65 cm × 50 cm
2003・Kaohsiung

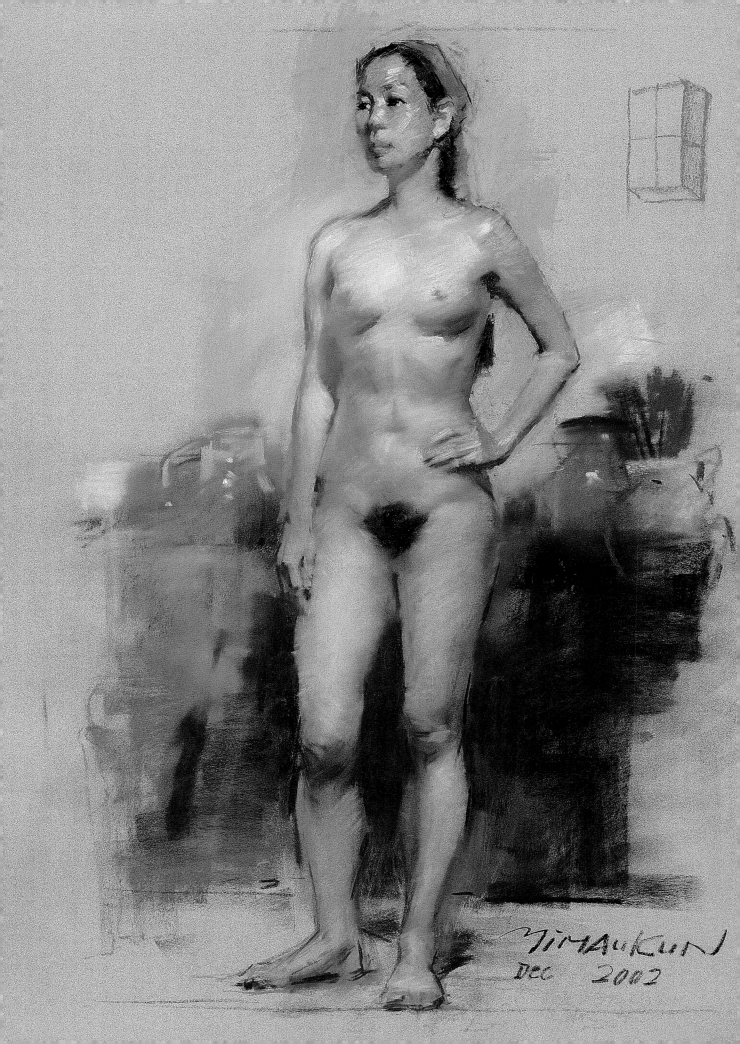

站立的裸女（1）
The Standing Nude (1)

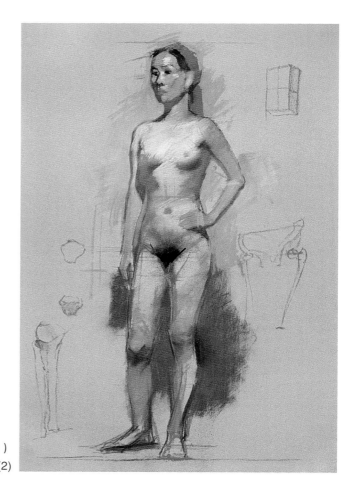

站立的裸女
65 cm × 50 cm
2002・高雄
The Standing Nude
65 cm × 50 cm
2002・Kaohsiung

站立的裸女（2）
The Standing Nude (2)

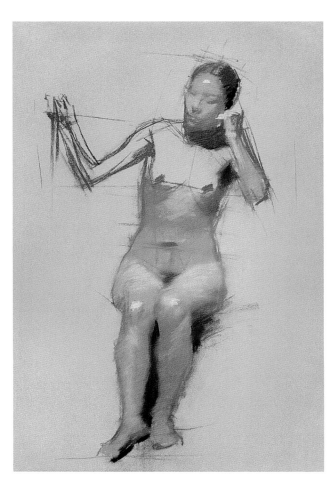

坐着的裸女（1）
The Sitting Nude (1)

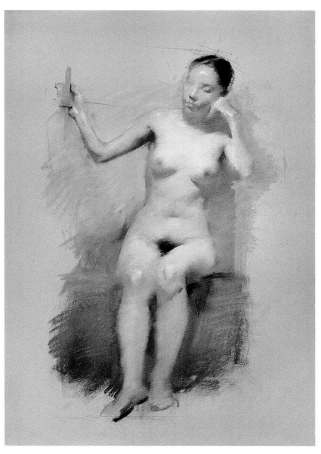

坐着的裸女（2）
The Sitting Nude (2)

坐着的裸女
65 cm × 50 cm
2002・台南
The Sitting Nude
65 cm × 50 cm
2002・Tainan

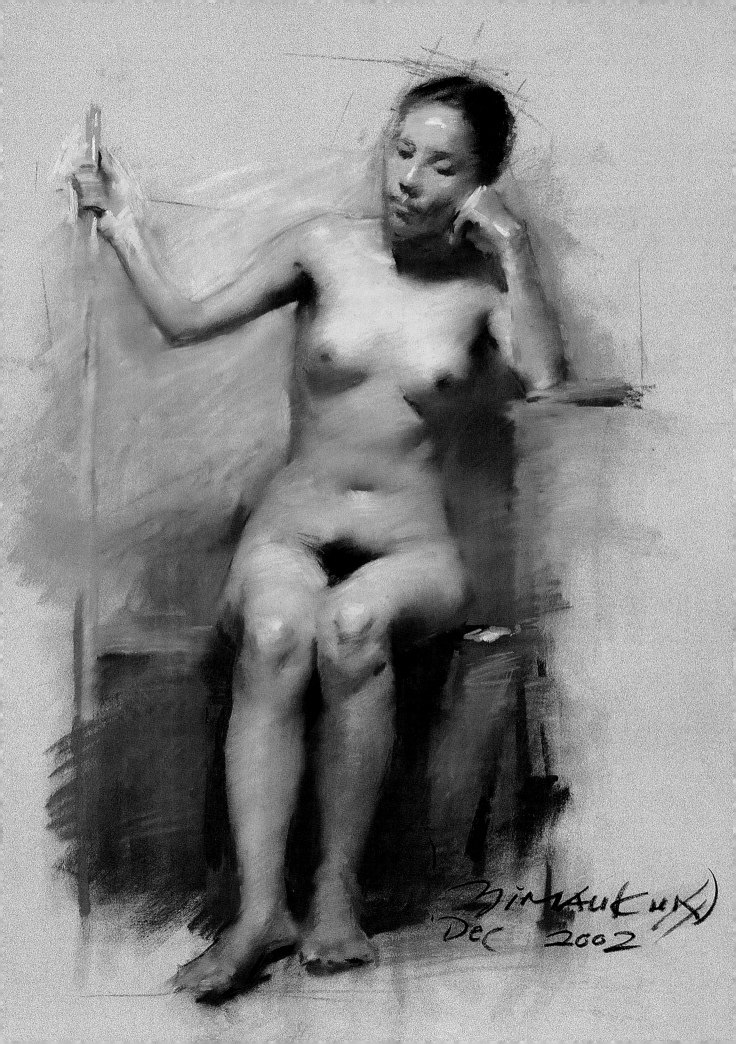

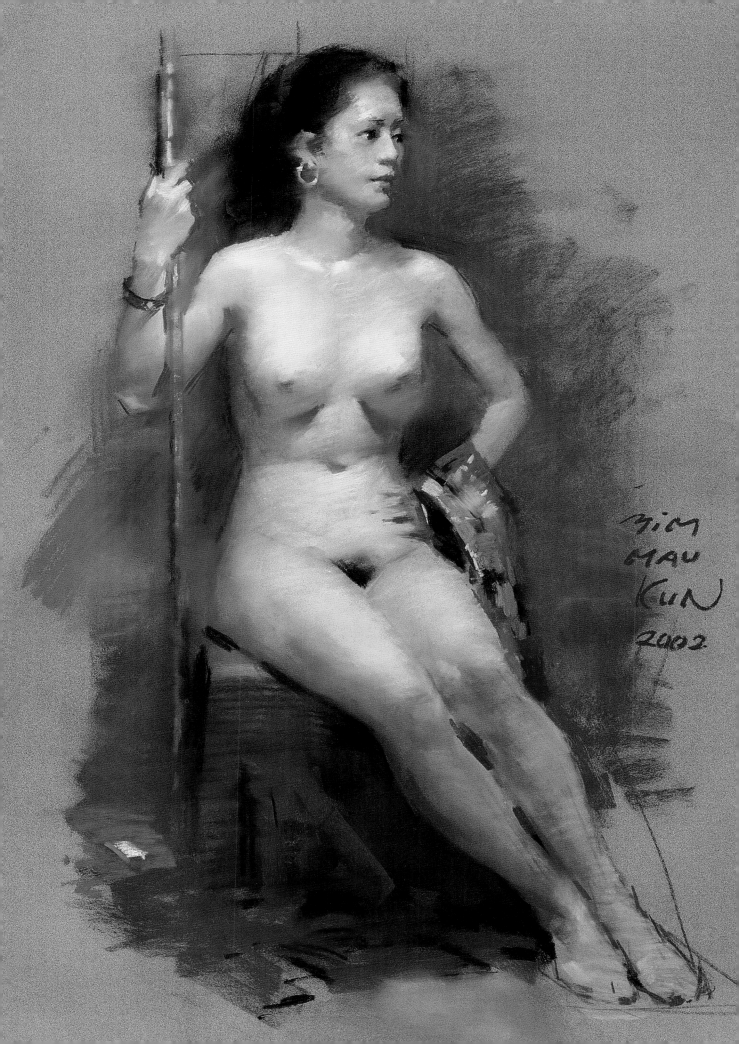

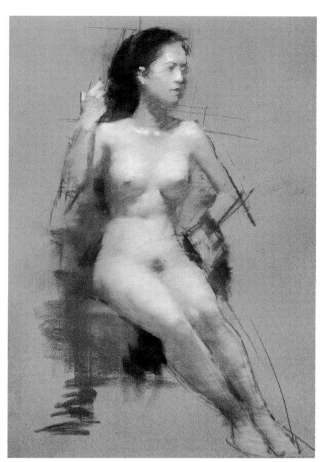

右手握钢管的
坐姿裸女（1）
The Sitting Nude Holding
a Steel Stick (1)

右手握钢管的
坐姿裸女
65 cm × 50 cm
2002・台北
The Sitting Nude Holding
a Steel Stick
65 cm × 50 cm
2002・Taipel

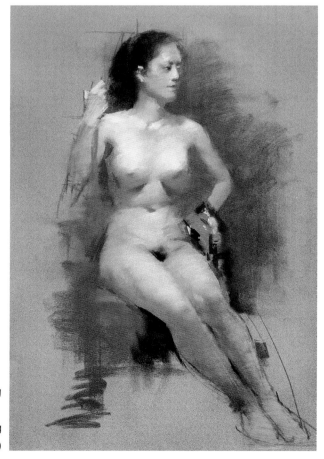

右手握钢管的
坐姿裸女（2）
The Sitting Nude Holding
a Steel Stick (2)

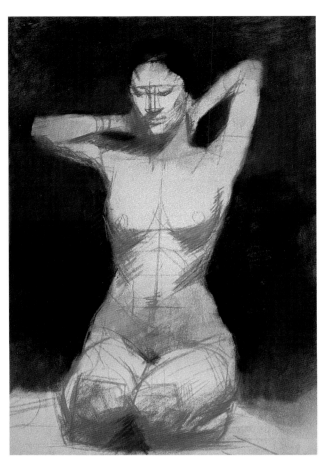

跪着的裸女（1）
The Kneeling Nude (1)

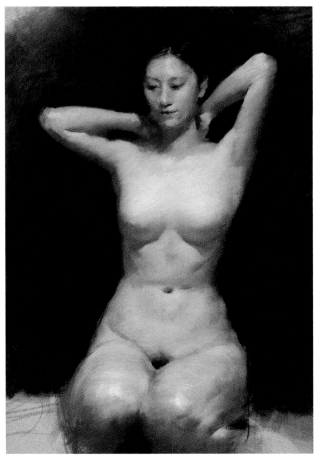

跪着的裸女（2）
The Kneeling Nude (2)

跪着的裸女
65 cm × 50 cm
2002・台北
The Kneeling Nude
65 cm × 50 cm
2002・Taipei

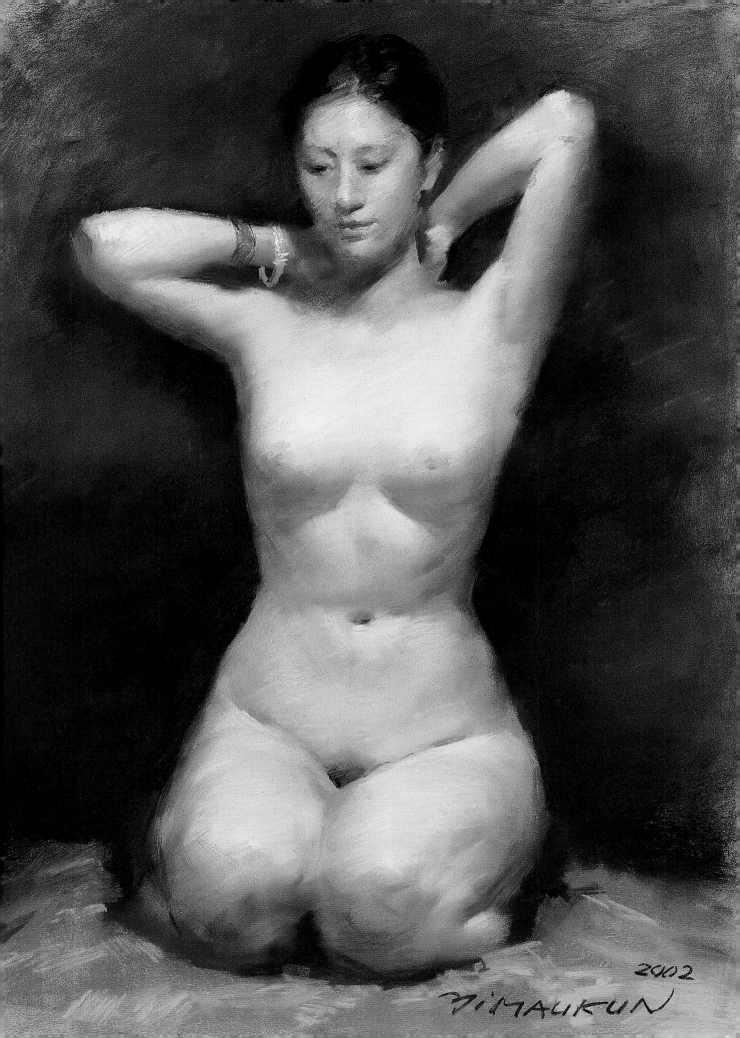

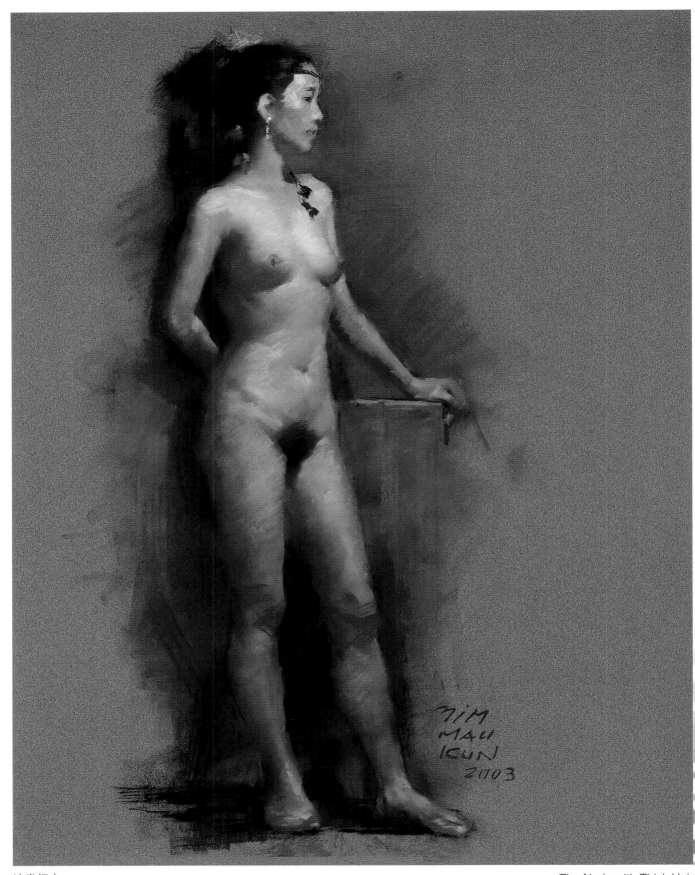

浓发裸女
65 cm × 50 cm
2003 · 台南

The Nude with Thick Hair
65 cm × 50 cm
2003 · Tainan

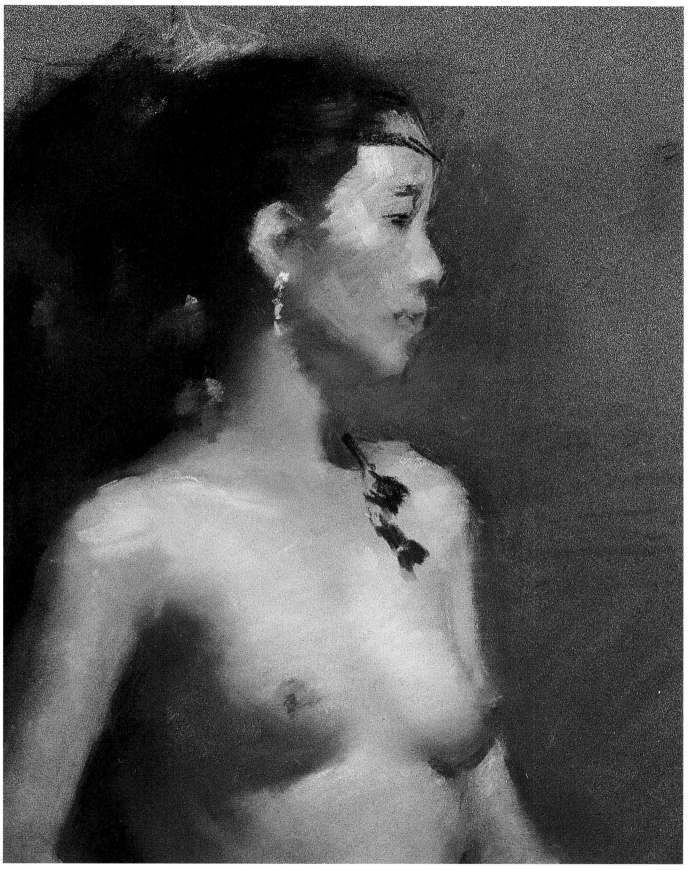

浓发裸女（局部）

The Nude with Thick Hair (portion)

着蓝花裙的美国姑娘（1）　The American Girl in Blue Skirt (1)

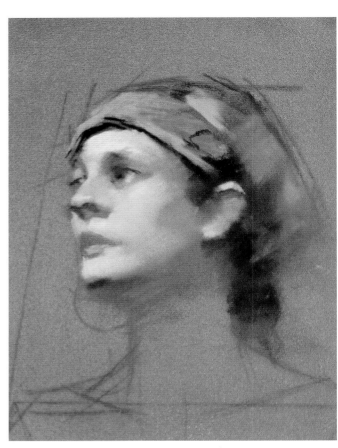

着蓝花裙的美国姑娘（2）　The American Girl in Blue Skirt (2)

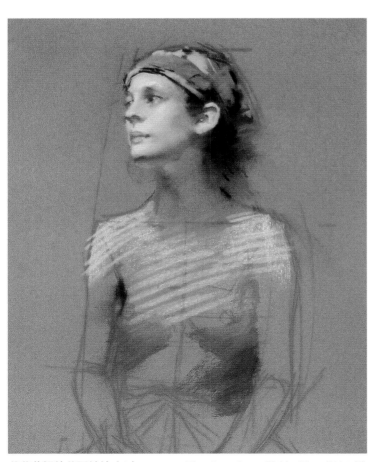

着蓝花裙的美国姑娘（3）　The American Girl in Blue Skirt (3)

着蓝花裙的美国姑娘
65 cm × 50 cm
2003・高雄
The American Girl in Blue Skirt
65 cm × 50 cm
2003・Kaohsiung

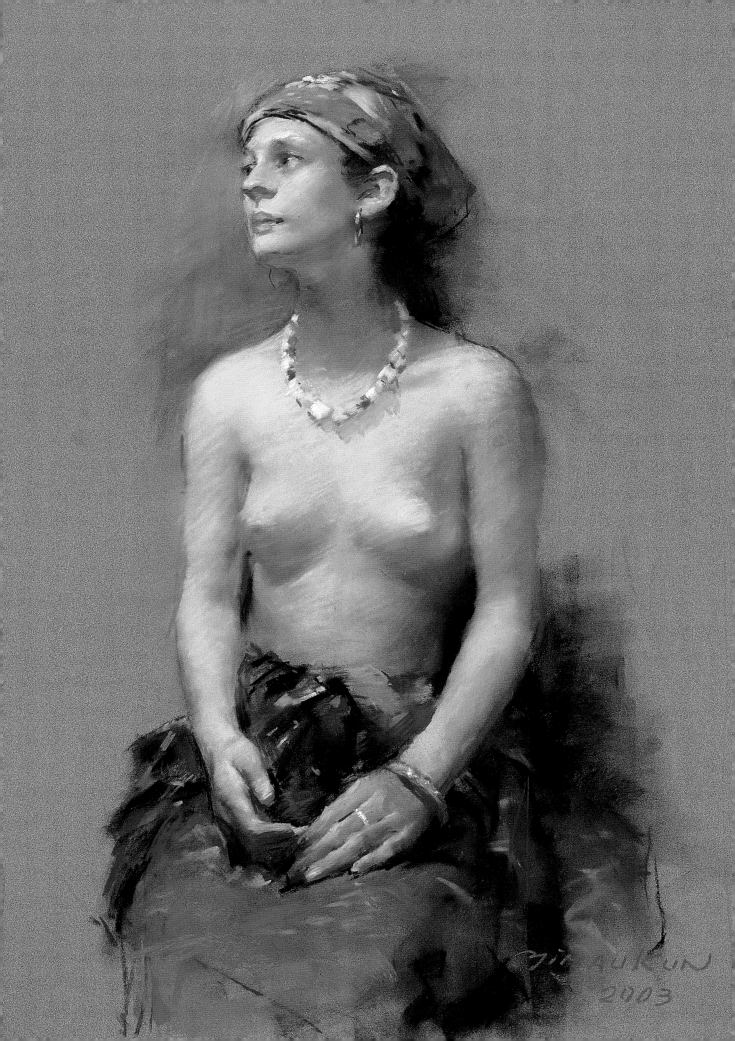

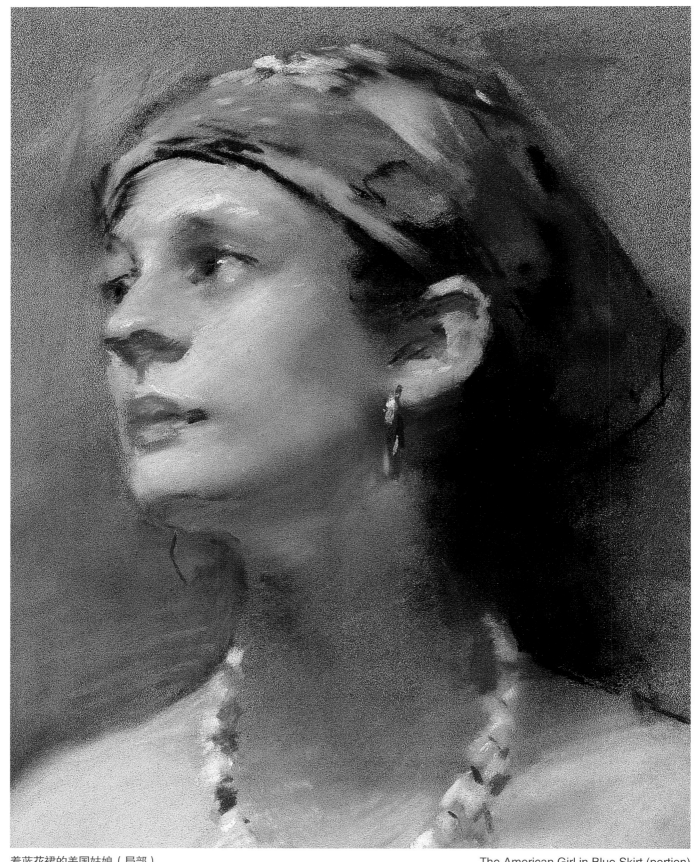

着蓝花裙的美国姑娘（局部）

The American Girl in Blue Skirt (portion)

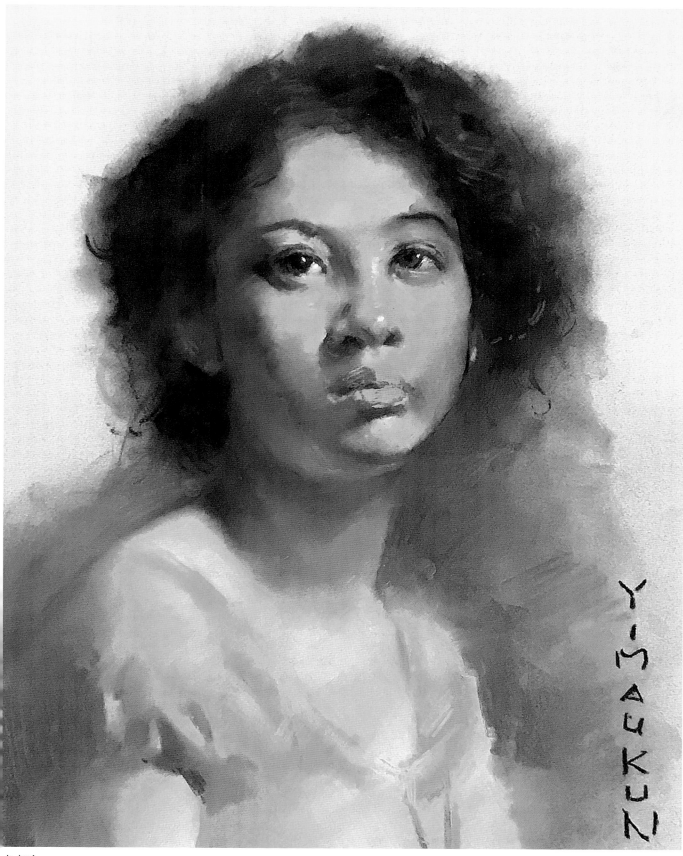

卢贞吟

60 cm × 39 cm

2020・台北

Lu Zhenyin

60 cm × 39 cm

2020・Taipei

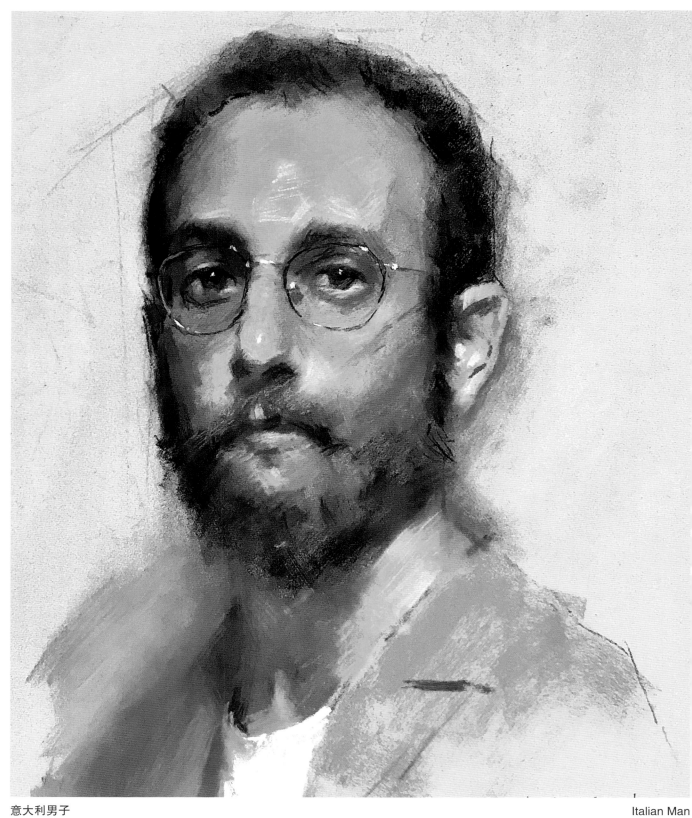

意大利男子
65 cm × 50 cm
2020・台北

Italian Man
65 cm × 50 cm
2020・Taipei

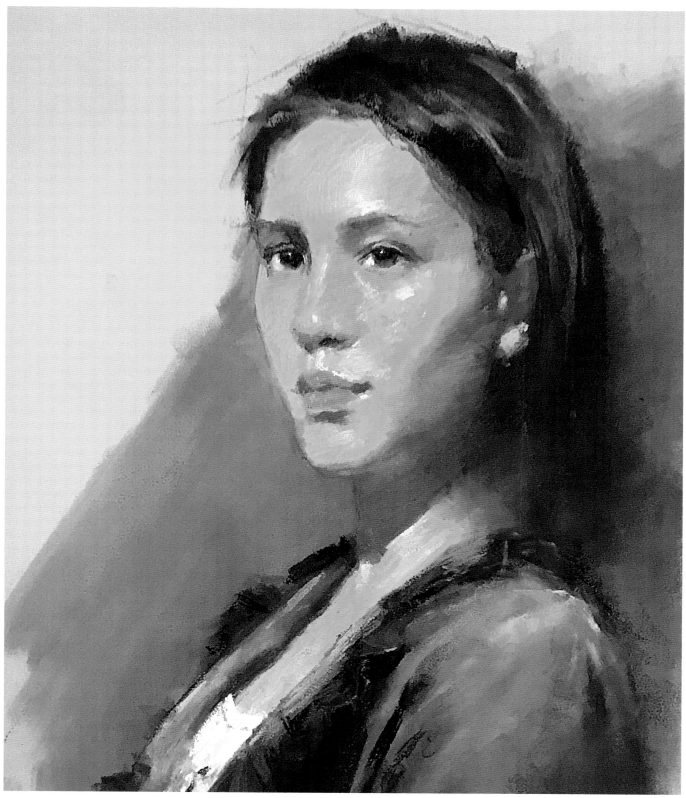

瑜萱
65 cm × 48 cm
2020・台北

Yuxuan
65 cm × 48 cm
2020・Taipei

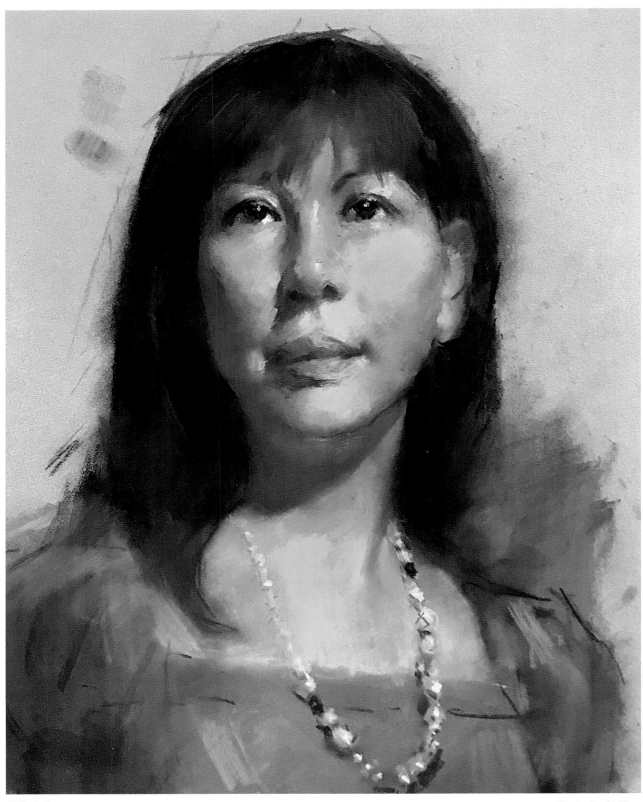

怡伶头像
60 cm × 40 cm
2020・台北

Portrait of Yiling
60 cm × 40 cm
2020・Taipei

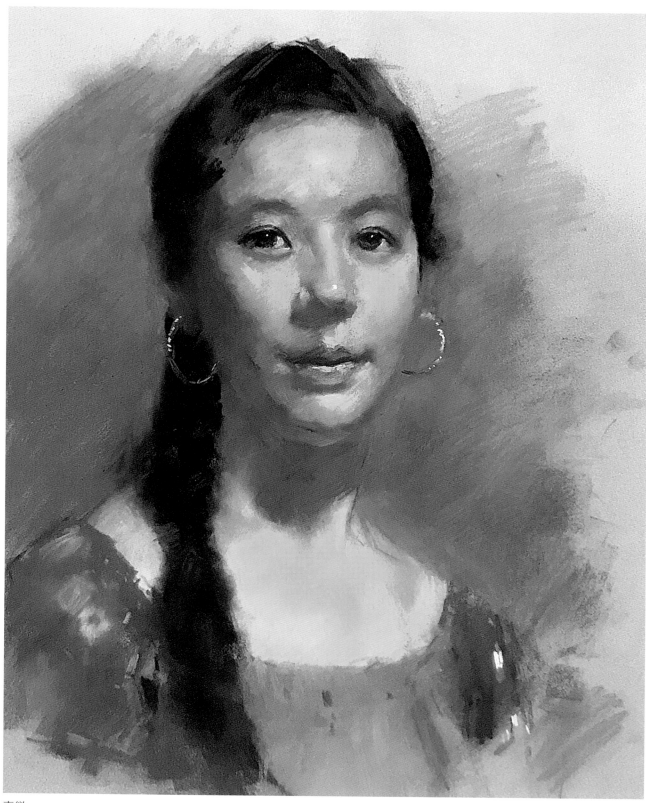

嘉微
60 cm × 40 cm
2020・台北

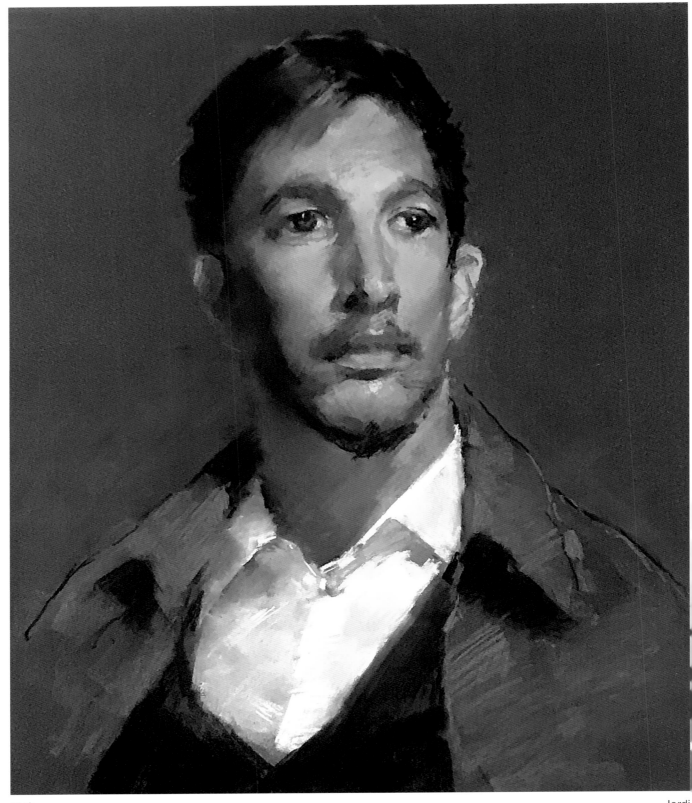

乔迪
65 cm × 50 cm
2020・台北

Jordi
65 cm × 50 cm
2020・Taipei

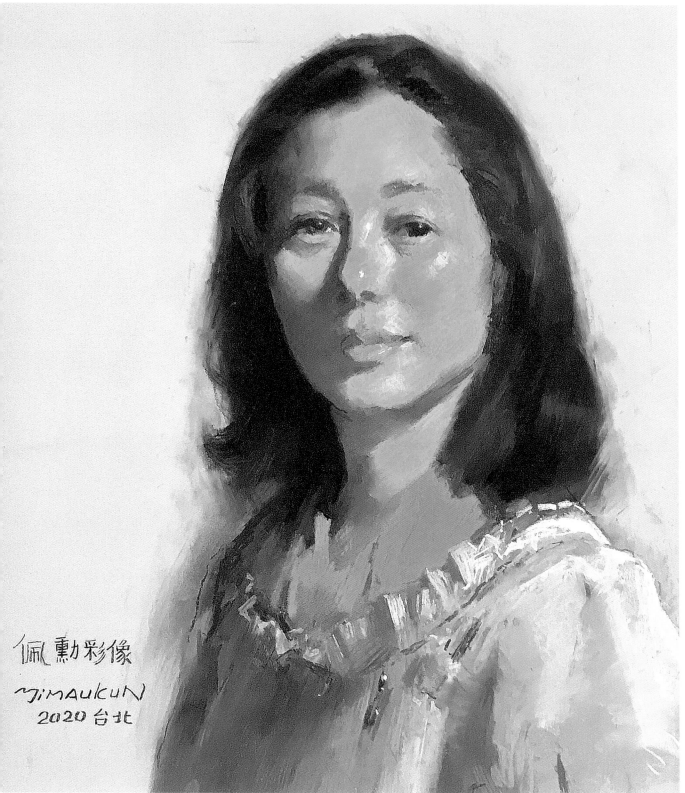

佩勋彩像
66 cm × 51 cm
2020・台北

Portrait of Peixun
66 cm × 51 cm
2020 ・ Taipei

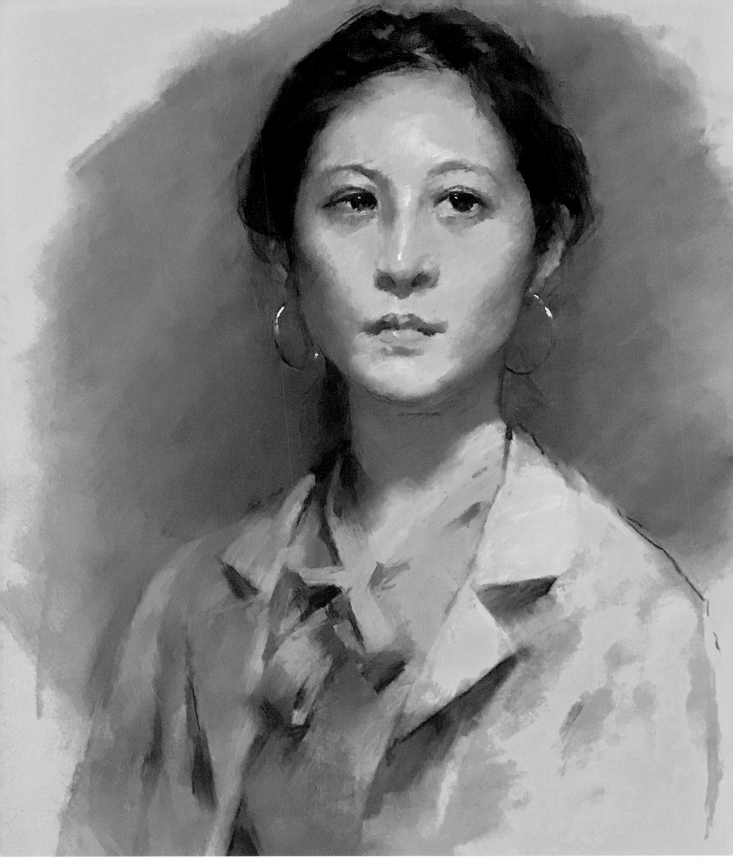

丁娜
65 cm × 50 cm
2020・台北

Dinna
65 cm × 50 cm
2020 ・ Taipei